D1219271

APPALACHIA USA

PHOTOGRAPHS BY

BUILDER LEVY

APPALACHIA USA

PHOTOGRAPHS BY

BUILDER LEVY

DAVID R. GODINE · PUBLISHER

BOSTON

First published by
DAVID R. GODINE · PUBLISHER
Post Office Box 450
Jaffrey, New Hampshire 03452
www.godine.com

LIBRARY OF CONGRESS CATALOGING-IN-PUBLICATION DATA

Levy, Builder.
Appalachia USA : photographs, 1968-2009 / by Builder Levy. -- First Edition.
 pages cm
 ISBN 978-1-56792-508-1 (alk. paper)
1. Coal miners--Appalachian Region--Pictorial works. 2. Coal mines and
mining--Appalachian Region--Pictorial works. I. Title.
 HD8039.M62U6436 2013
 338.2'724097409045--dc23

 2013021216

FIRST EDITION
Printed in the U.S.A.

Contents

Foreword

BUILDER LEVY first arrived in the coalfields of the central Appalachian Mountains in 1968. He has returned many times to capture this region, with an eye as discerning and loving as any native's. I am a child of the place Levy has chronicled so faithfully. I grew up in the coal camp of Black Wolf, in McDowell County, West Virginia, which once bragged of being "the heart of the million-dollar coalfield." When I study Levy's photographs, I see the faces of people similar to my relatives and neighbors. I see homes and churches like mine, battered but intriguing towns like those on my "holler." The details of coal-grimed miners' faces, wooden porch railings, dusty roads slicing past creeks and company houses, craggy winter mountains shorn of their foliage but still possessing a rough beauty—all recall my childhood. They make me weep for my losses.

Like the rest of the community, my family's survival was dependent upon the prosperity of the mine. When the market for coal was good, families prospered. When it was not—and it *usually* was not—we suffered hard times. My grandfather and uncles worked underground and my father kept the books for Page Coal and Coke. One of my father's jobs at the end of each day was to post one of two wooden signs outside the payroll office. One sign read "Work Tomorrow," the other, "No Work Tomorrow." A sad joke paraphrased the words of a funeral service: "Coal giveth, and coal taketh away." When I was thirteen, the local mine, and many others, closed, and we moved away to the state capital, Charleston. The coalfields were lost for me, and for thousands of others, forever. How wonderful, then, to find my beloved place still alive in Builder Levy's photographs.

DENISE GIARDINA

Preface

SPANNING MORE THAN four decades (1968–2009), the photographs in this book emerged from multiple visits to coalfield Appalachia. I wanted to see and experience America by spending time in and exploring what I felt was a significant yet little understood and often overlooked region of the United States.

Once the hunting grounds of the Cherokee and other indigenous groups, Appalachia became the home of colonists seeking to escape the oppressive rule of the British. Later, it was marked by the routes and hideouts of slaves escaping on the Underground Railroad. Appalachia was a crucible of abolitionism, where 250,000 southern mountaineers volunteered for the Union army during the Civil War. A dramatic change to the way of life in these mountains came with the building of railroads and the opening of large coal mines, beginning in the late nineteenth century. Recruited from the surrounding subsistence farms, from towns and villages all over Europe, from African American communities in the South, and southern prison conscript labor, Appalachian miners have toiled underground, facing the daily threat of lung disease, injury, and death to feed their families and to provide the coal that has helped build and sustain our nation. Since then, miners have struggled collectively, despite the resistance of some of the most powerful industrial and corporate forces on earth, to make a better life for themselves, their families, their communities, and the American people.

When my first book, *Images of Appalachian Coalfields*, was published in 1989, I thought the project finished. But by then, big changes were already occurring in the central Appalachian landscape. In addition to an increasing proliferation of enormous toxic liquid coal waste reservoirs, mountaintop removal surface mining—the most efficient yet most destructive form of coal extraction—was becoming the dominant process, destroying communities that had existed for generations and threatening to erase a region's way of life.

As the end of the twentieth century approached, the idea of returning to do more photography to update this ongoing obsession began to percolate in my mind. I returned to Appalachia to "complete" this work. Since the new millennium, I have visited new and old places in the coalfields, met new people, made new friends, and reconnected with old ones. In addition, I have made ten flights over southern West Virginia and eastern Kentucky in a four-seat Cessna. These flights opened a whole new perspective on the current massive mining operations.

The mountains themselves—the most biodiverse in North America and among the oldest in the world—have been central to my interests. My primary focus remains, however, the quotidian life of the people and their enduring humanity.

BUILDER LEVY

SOCIAL LANDSCAPE

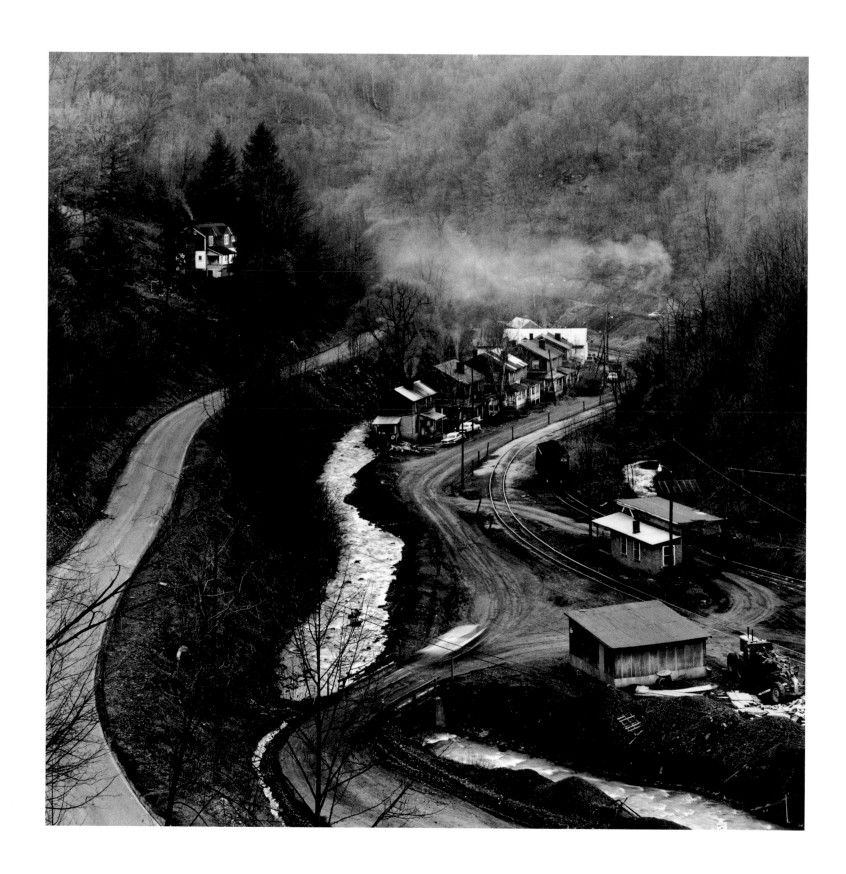

1 · Coal Camp

1 *Coal Camp,* near Grundy, Buchanan County, Virginia, 1970. The mountains were steep and stark. Coming from Kentucky, we were heading east on U.S. 460. I slowed down to look at this remnant of a coal camp—originally a community built and owned by a coal company to house the workforce for its nearby mine. Turning to my teaching colleague who had accompanied me on this week-long road trip through coalfield Appalachia, I said, "I wish I could have photographed that scene!" He replied, "Why not?" During the previous seven days we had passed many similar coal camps tucked into mountain hollows, but the light and vantage point had never seemed right. This time I pulled up onto the grass, set up my view camera on the tripod, quickly focused under the black cloth, inserted the film, and made the exposure just before the sun slipped below the mountain and the glow disappeared.

2 *Clover Fork* of the Cumberland River, Highsplint, Harlan County, Kentucky, 1974. During a lull in the tension and action of the strike at Duke Power Company's mine at Highsplint, I made this photograph from the Highsplint Bridge.

3 *Welch,* McDowell County, West Virginia, 2006. Since my earliest coalfield trips onward, whenever I drove on the Welch Bypass, I always thought about photographing the town of Welch, the county seat of what was for many decades the biggest coal-producing county in the nation and a town that played an important role in coalfield heritage. In the center of town, on the Welch courthouse steps, Matewan Chief of Police Sid Hatfield and his deputy Ed Chambers were shot by gunmen from the Baldwin-Felts Detective Agency on August 1, 1921. The year before, Hatfield, with the help of a large group of miners and the Matewan mayor, Cabel Testerman, had tried to arrest a contingent of armed detectives for forcibly evicting families of miners who, earlier that same day at the Stone Mountain Coal Camp on the outskirts of Matewan, had joined the union. A shootout erupted. Seven Baldwin-Felts agents, Mayor Testerman, and three miners were killed, and many people were injured. The assassination of Hatfield and Chambers the following year was a catalyst for more than 10,000 miners, carrying rifles, to march against the repressive conditions in the southern West Virginia coalfields. Headed toward Mingo County, they were confronted at Blair Mountain in Logan County by Sheriff Don Chaffin, his armed deputies, and about three thousand gunmen hired by the coal operators. The miners were actually winning the ensuing ground encounter, which took place from August 21 through September 2, 1921, and ceased only when the United States Army was called in. Many miners and their leaders were jailed, but the Battle of Blair Mountain, as it became known, is well remembered as a time when miners stood up for their right to organize and fight for a better life for themselves and their families.

4 *Montgomery,* Fayette County, West Virginia, 1978. Montgomery is significant as the birthplace of the Black Lung Association, in 1968. It is also home to the West Virginia Institute of Technology.

5 *Kermit,* Mingo County, West Virginia, 1968. On my first trip to the coalfields, I stopped in Kermit, a railroad and coal town on Route 52, separated from the mountains in Kentucky by the Tug Fork, a tributary of the Big Sandy River.

6 *Sheep Farm,* between Marianna and Cokeburg, Washington County, Pennsylvania, 1973. Before the mines opened up, subsistence farming was the way of life for the early settlers. Today, a few small farms, including this one, still manage to survive in coalfield Appalachia.

7 *Ellsworth,* Washington County, Pennsylvania, 1973. Behind the miners' homes and preparation plant are hills covered with coal slag. Parked in the foreground is my red 1966 Volkswagen convertible, my means of transportation to, from, and around the coalfields from 1968 through 1973. The Chicago industrialist James W. Ellsworth built the town in 1899 to provide a place to live for the workforce of his just-opened Ellsworth Collieries Company mines.

8 *Mount Olive Baptist Church,* Stirrat, Logan County, West Virginia, 1970. I had been looking to photograph a Walker Evans–like white wooden church next to a coal mine tipple. Instead, during a trip from Williamson to Morgantown, I found the Mount Olive Baptist Church, adjacent to the Wheeling Steel Corporation preparation plant. The church, on Old Route 119, was run by and for African American coal miners and their families.

9 *Prepare to Meet God,* Williamson, Mingo County, West Virginia, 1971. As I approached Williamson on Route 52 from the southeast, I saw this roadside sign. Then, as I entered the town I saw another sign, less photogenic but complementary to this one, that read, "Welcome to Williamson, Home of the Billion Dollar Coalfields."

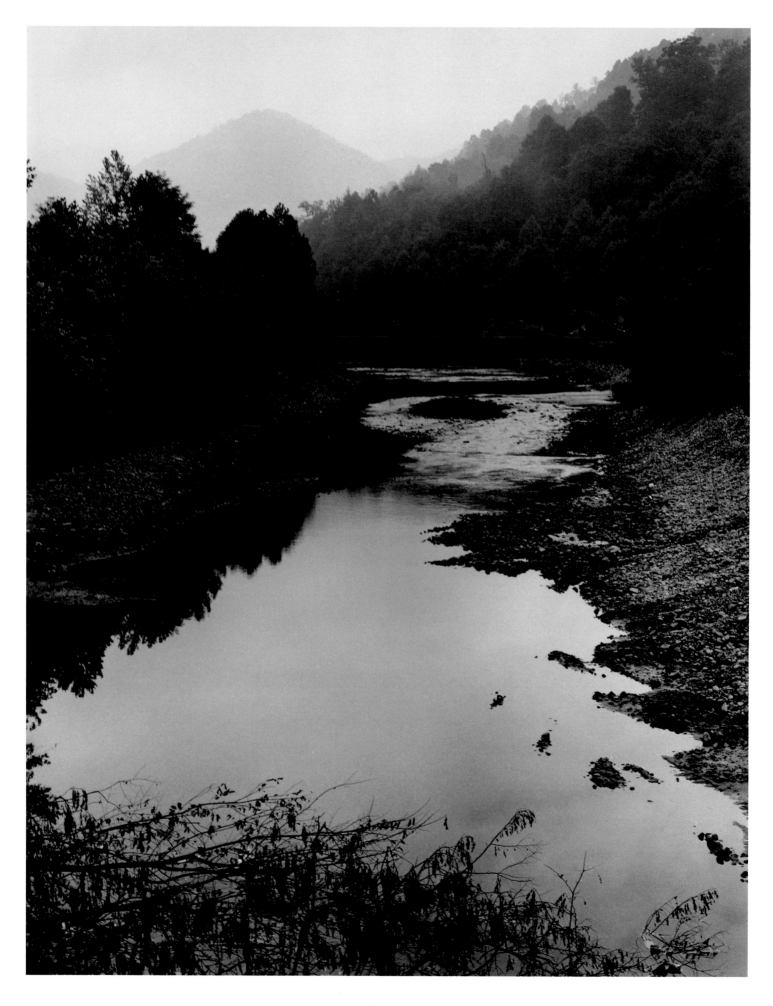

2 · Clover Fork

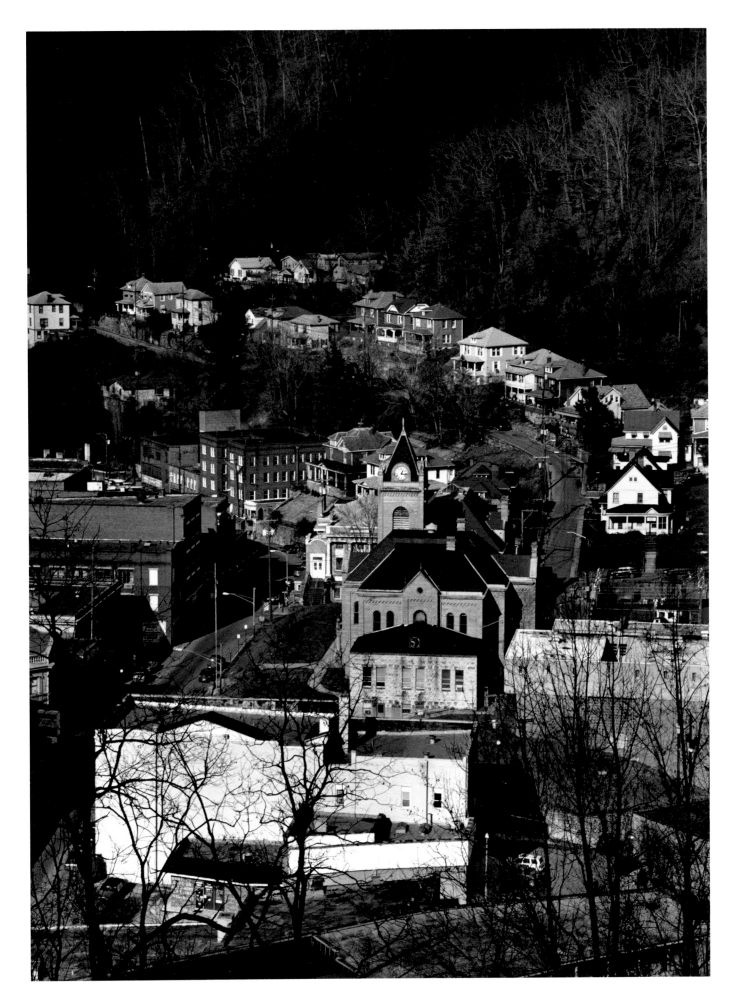

3 · Welch

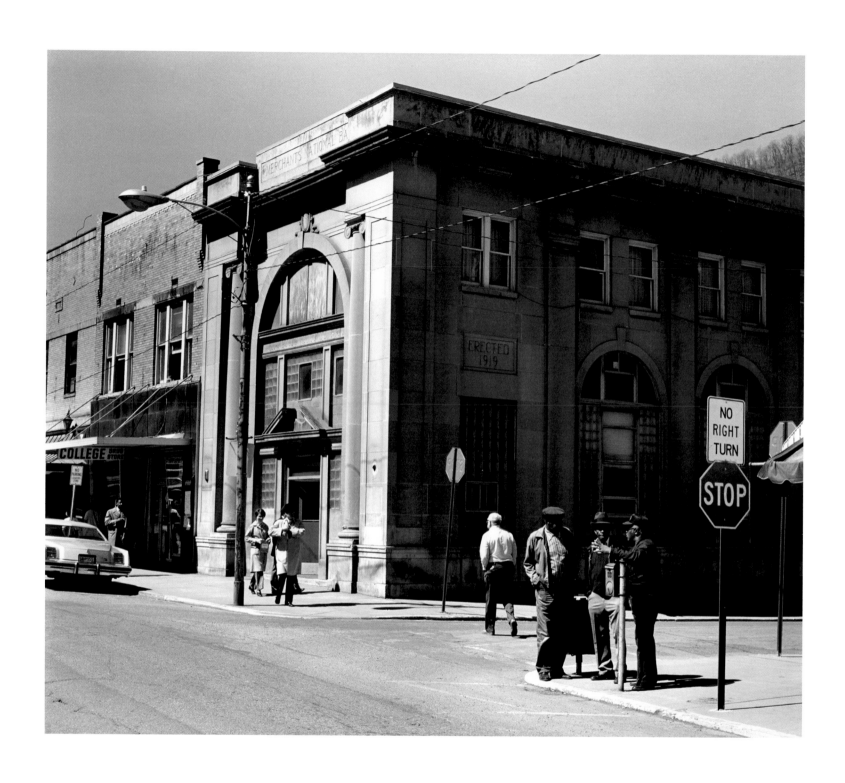

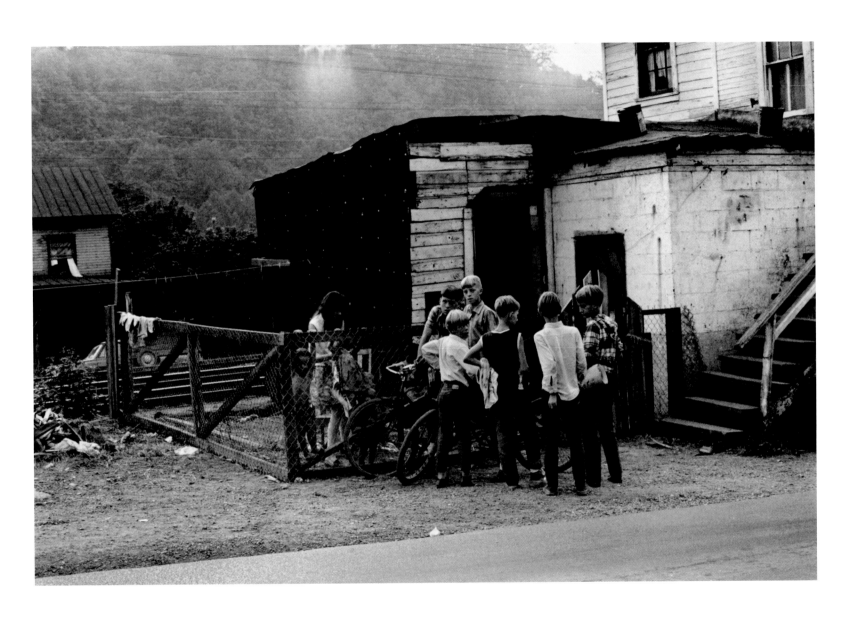

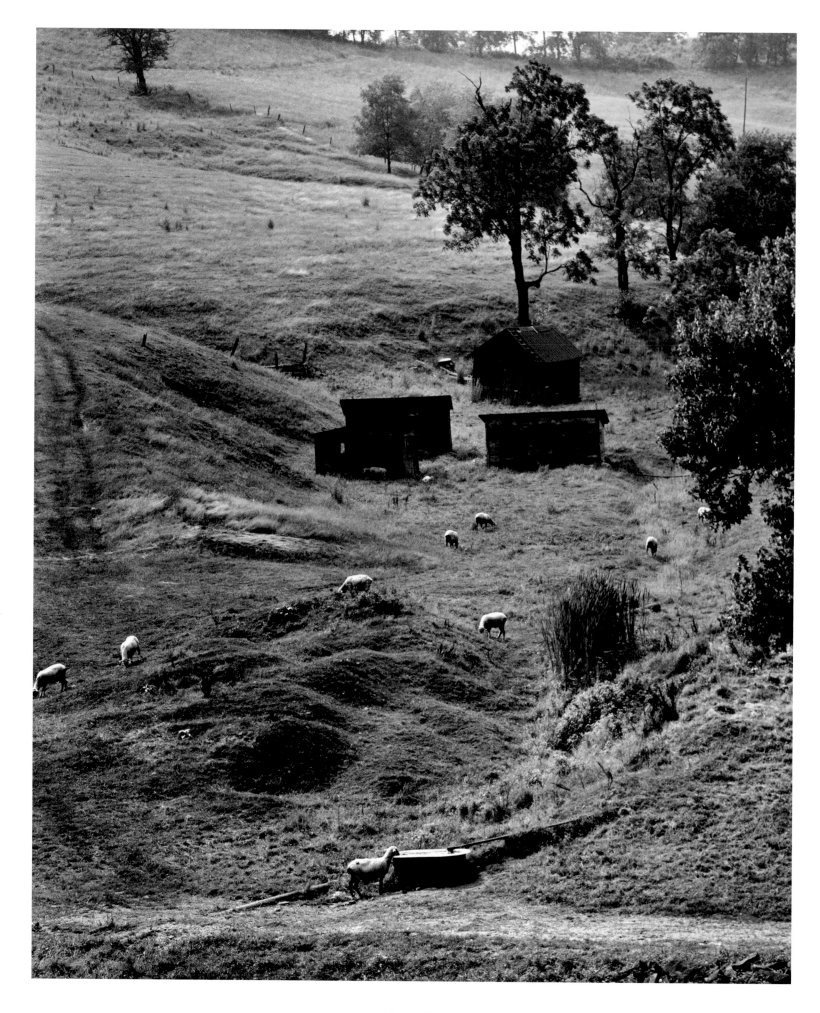

6 · Sheep Farm

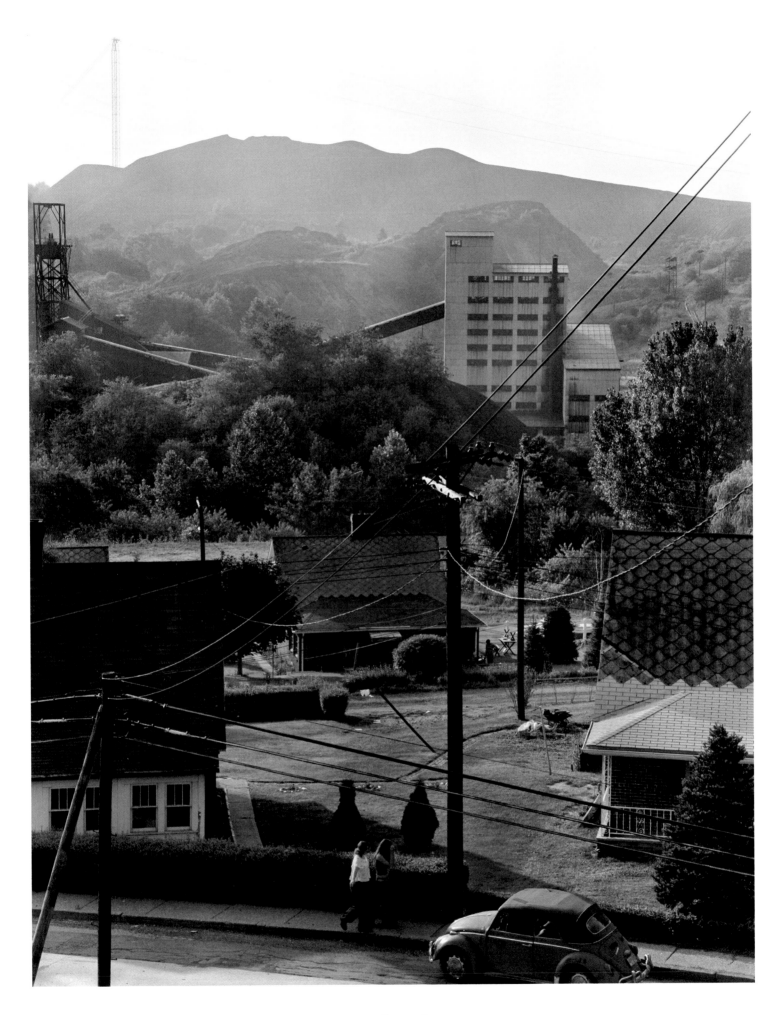

7 · Ellsworth

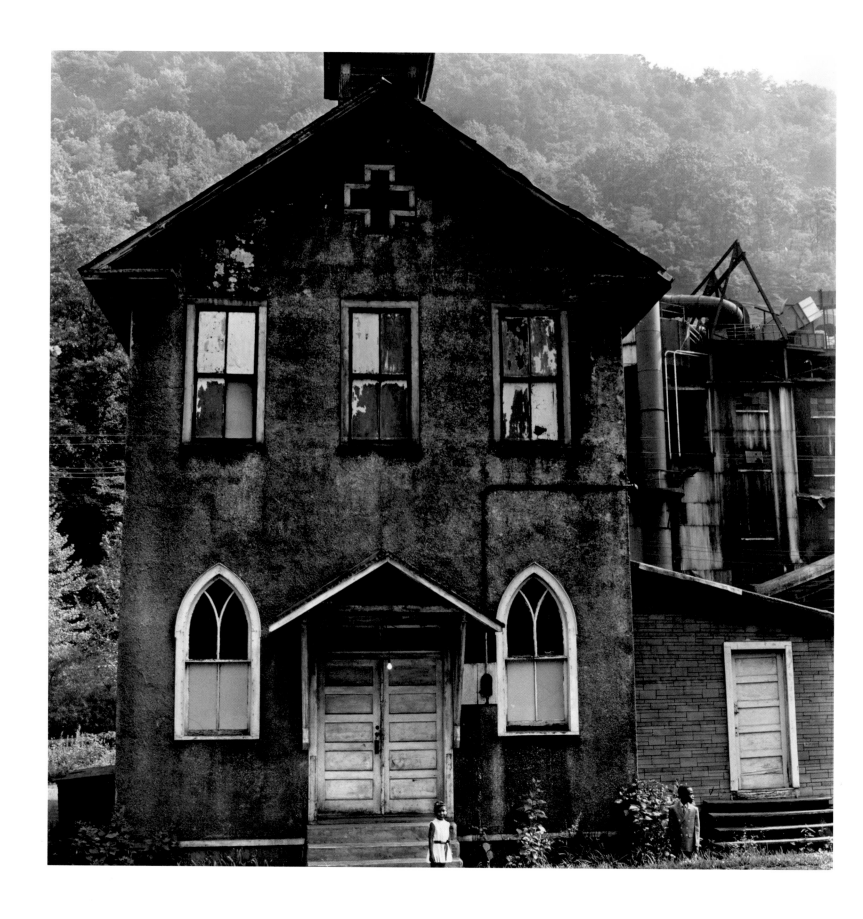

8 · Mount Olive Baptist Church

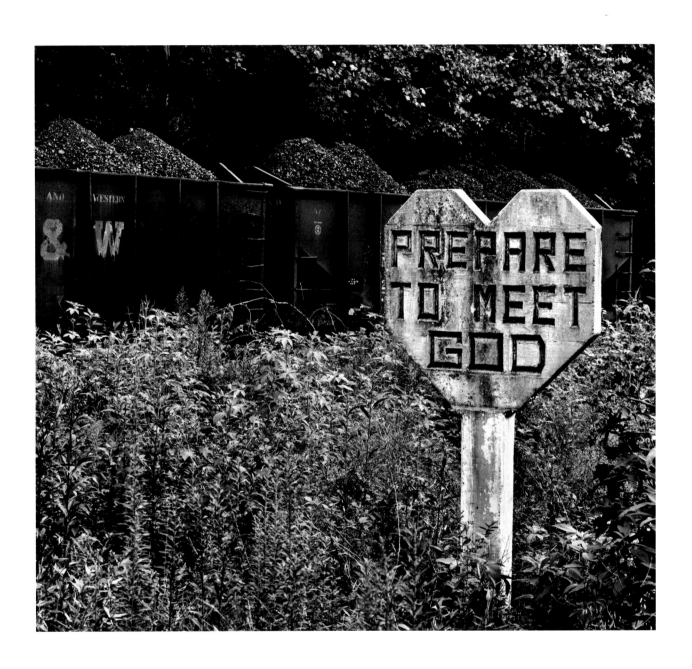

10 *Post Office,* Ages Brookside, Harlan County, Kentucky, 2002. In 1973, I had visited and photographed the Brookside strike picket line at this same location. Since my trips in 1973 and 1974, the road had been straightened and the Brookside Camp had been emptied and torn down, while conveyors and a truck-loading tipple had been added on the hillside.

11 *Old Preparation Plant,* southeast of Welch on Route 52, McDowell County, West Virginia, 1971.

12 *Caretta,* McDowell County, West Virginia, 2003. On a number of trips to Appalachia since the new millennium, I stayed in the third floor dormitory of Big Creek People in Action, also known as the Caretta Community Center. Impressed by the light on the mountains on this brisk March morning, I opened a window to make this photograph. The three women at the fence—Christine Greene, Alison Inman, and Annetta Tiller—were AmeriCore workers at the center.

13 *Keystone,* McDowell County, West Virginia, 1971. Driving southeast from the Williamson area on Route 52, I had missed the turnoff for a Black Lung Association rally in Gilbert, Mingo County, when I happened upon this outdoor savior meeting in Keystone Bottom.

14 *Clifftop Window,* Fayette County, West Virginia, 1973. In an earlier day, when Clifftop was a company town, this general store and post office were where miners' families would buy supplies and food. Since miners were paid in scrip and not U.S. currency, they and their families had no alternative but to shop at the company store. Credit was extended to families in need, but if a miner and his family wanted to leave, he would first have to work off all his debt.

15 *Red Robin Inn,* Borderland, Mingo County, West Virginia, 1971. I found this collection hanging on a wall in Charlie Blevins's small road-stop on Route 52 northwest of Williamson. Blevins was a retired miner and World War II veteran. His father had been one of the many Mingo County miners striking for a union contract whose families were evicted from their company homes and had to spend the cold winter of 1920–21 in a tent colony. Blevins relocated to the Kentucky side of the Tug Fork when he was forced under eminent domain to sell his Borderland property to the state for highway expansion. In June 2004, I visited Charlie in his Kentucky home, which included his rebuilt Red Robin Inn, set up for show but no longer a commercial road-stop. Although Charlie had black lung disease and used an oxygen tank much of the time, he played one of his banjos and sang for me. Two months later, Blevins passed away. The photograph hanging in the wall collection is of Martha Horn, his wife's grandmother.

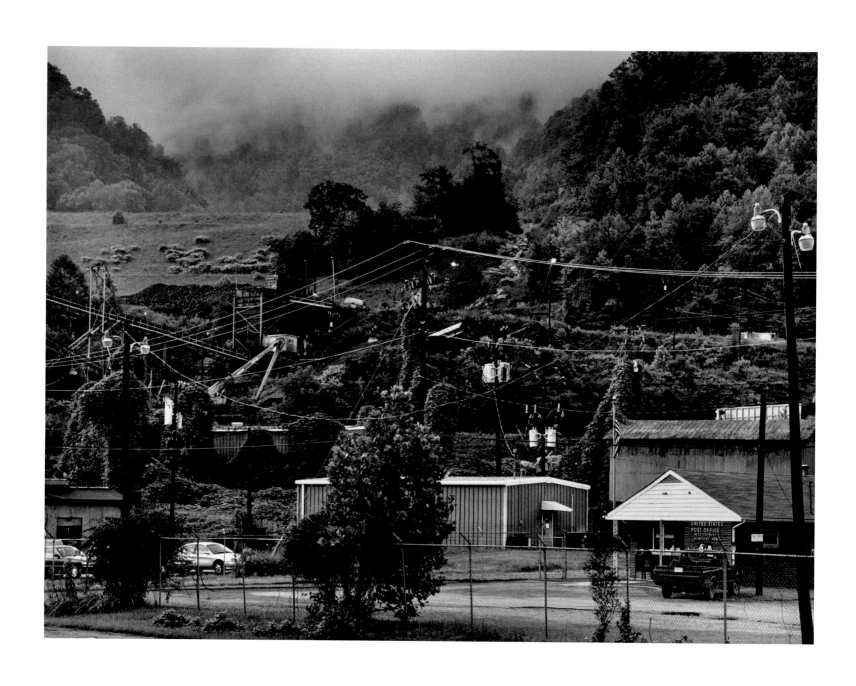

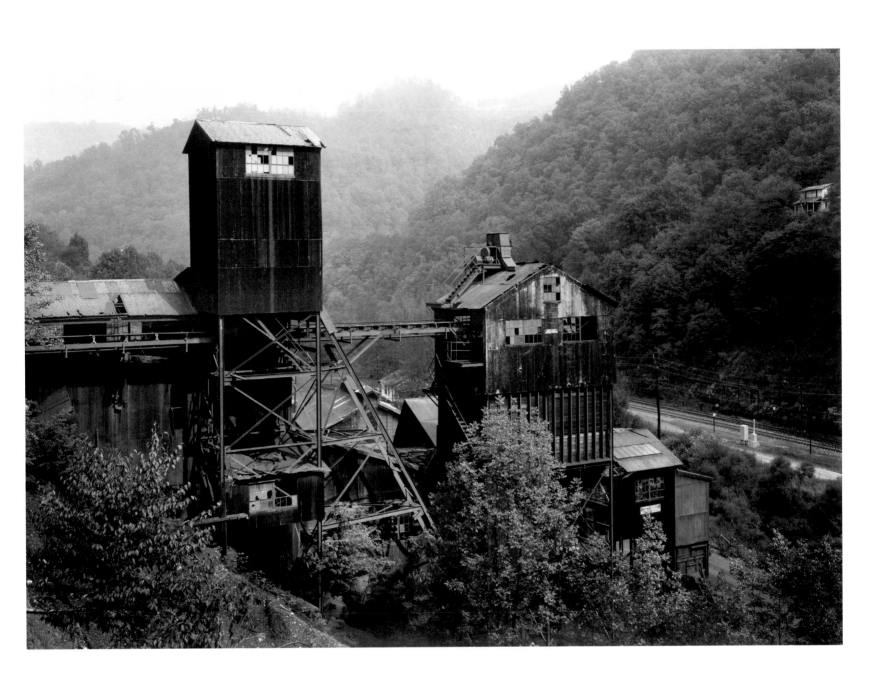

11 · Old Preparation Plant

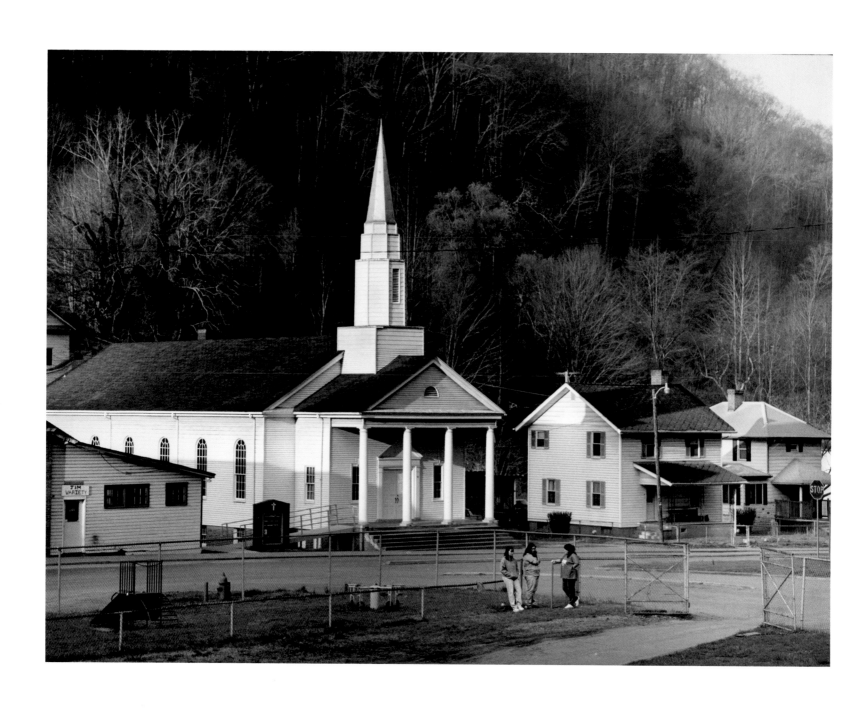

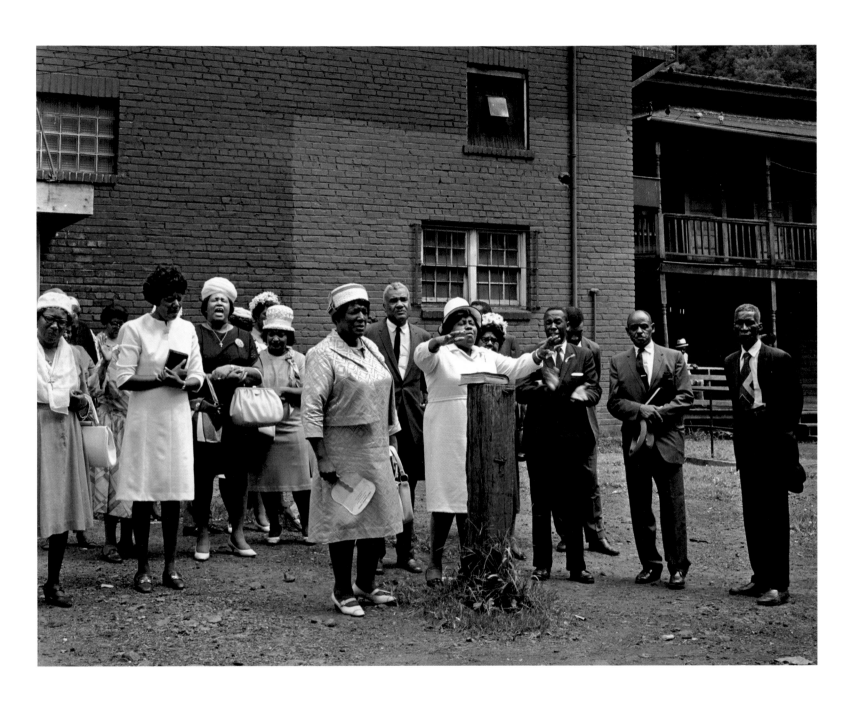

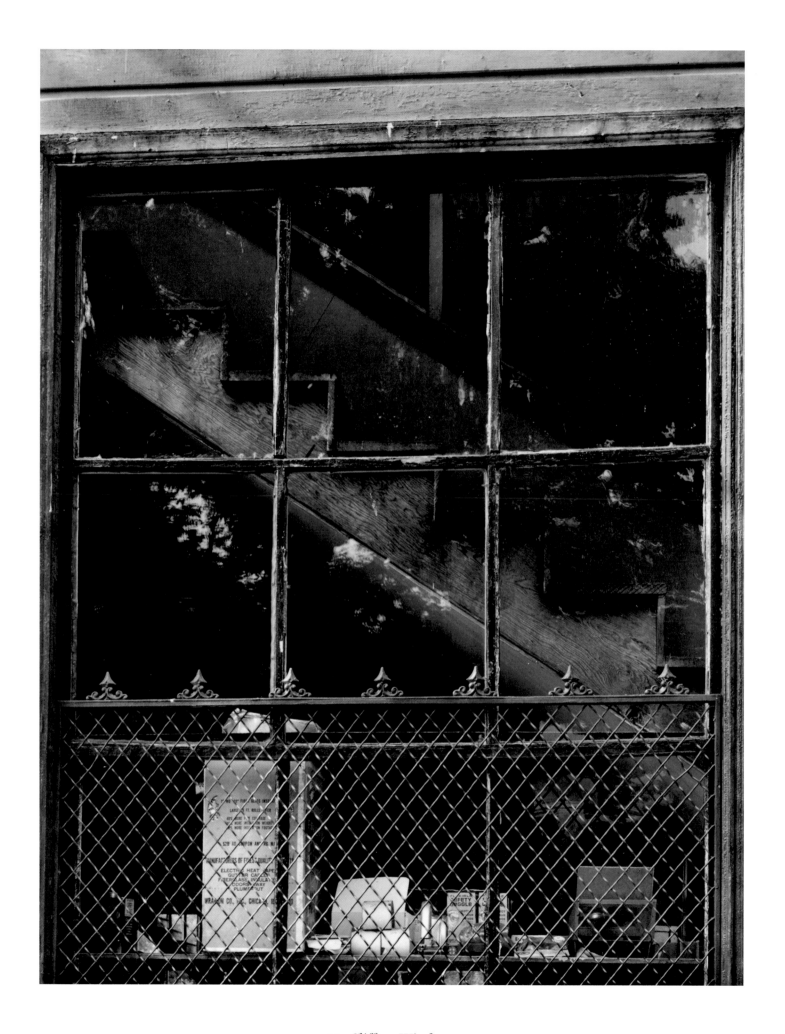

14 · Clifftop Window

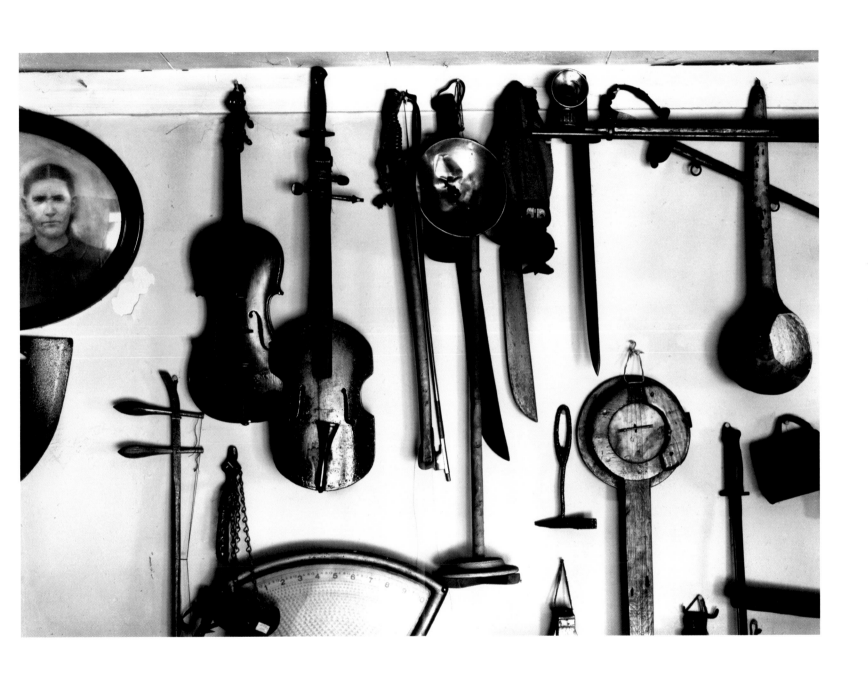

HOME, FAMILY, CHILDREN

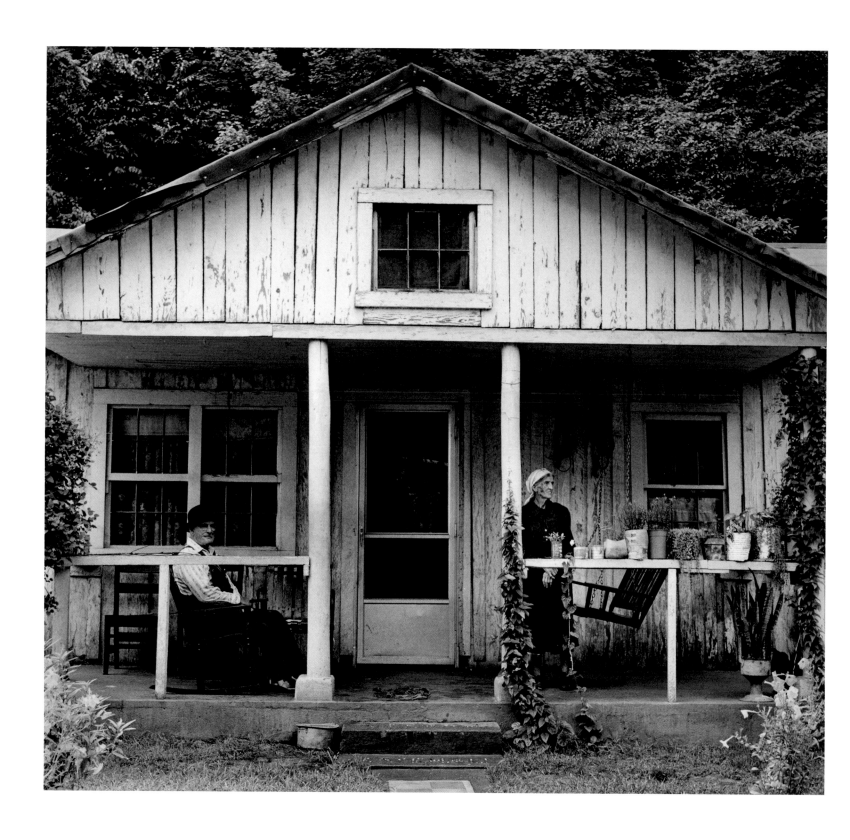

16 *House and Flowers,* Myrtle, Mingo County, West Virginia, 1972. In the summers of 1971 and 1972, Alice Deutsch (now my wife) and I rented a room in the home of a retired miner, George Johnson; his wife, Grace; and their teenage granddaughter, Sandy. One day George took us to visit his two older sisters. One of them, along with her brother, stayed out on the porch while I made this photograph.

17 *Lidge Hunter's House,* Chattaroy, Mingo County, West Virginia, 1972.

18 *William Marcum,* between Naugatuck and Williamson, Mingo County, West Virginia, 1970.

19 *Preachers,* Sprigg, Mingo County, West Virginia, 1970. It was a Sunday morning. I had just visited Matewan and was heading back to Williamson, where I was staying in the home of a VISTA worker. I stopped to make photographs of a group of African Americans congregating outside their church. The service, I was told, had just ended. Nearby, a few white families were entering a plain, coal-company-type house to begin their own service. I walked over to them and upon my request they welcomed me into their small, homespun, self-run church to photograph. In 2004, when I was revisiting Charlie Blevins, I gave him a set of reproductions from my portfolio *Life of the Appalachian Coal Miner.* On seeing this photograph, he told me he knew those men, his friends Johnny Crabtree and Jim Ed Whitt, both coal miners like himself.

20 *The Church Family,* Thacker Mines, Mingo County, West Virginia, 1970. On this July day I drove through several coal camps before stopping to talk to and photograph Ellis and Vivian Church, their sons, and a nephew on the porch of their house. After working in mines for twenty-two years, Ellis was permanently disabled by a roof fall—a chunk of slate from the mine ceiling fell on him.

21 *Mae Phillips and Granddaughter Jeanie,* Kildav, Harlan County, Kentucky, 1974. Mae Phillips was the widow of a miner. During the historic thirteen-month strike against Eastover's mines at Brookside and Highsplint, I rented a room in the home of Gussie Mills, another miner's widow, who lived with her sixteen-year-old son, Brice, Junior. Next door to them lived Mae Phillips and her two granddaughters.

22 *Lula Shepherd,* Wipple, Fayette County, West Virginia, 1973.

23 *Lucious Thompson with Destiny Clark and Delena Brooks,* Tom Biggs Hollow, McRoberts, Letcher County, Kentucky, 2002. Born on July 21, 1943, in Jenkins, Letcher County, Lucious Thompson worked in the mines for nineteen and a half years. Drafted into the U.S. Army in 1968, he served sixteen months in Korea and Vietnam. Before becoming a miner, he had worked as a Kentucky power lineman and a hospital orderly; after retiring from the mines, he worked on a road construction crew. The Teco Coal Company had been engaged in mountaintop removal mining on the land above his double-wide mobile home, causing its cinder-block foundation to crack and the new addition to separate from the trailer. An activist with Kentuckians for the Commonwealth, an organization trying to stop mountaintop removal mining, Lucious was chairing a gathering of the group when I first met him in Fleming-Neon, down the road from McRoberts.

24 *Sisters,* Osage, Scotts Run, Monongalia County, West Virginia, 1970.

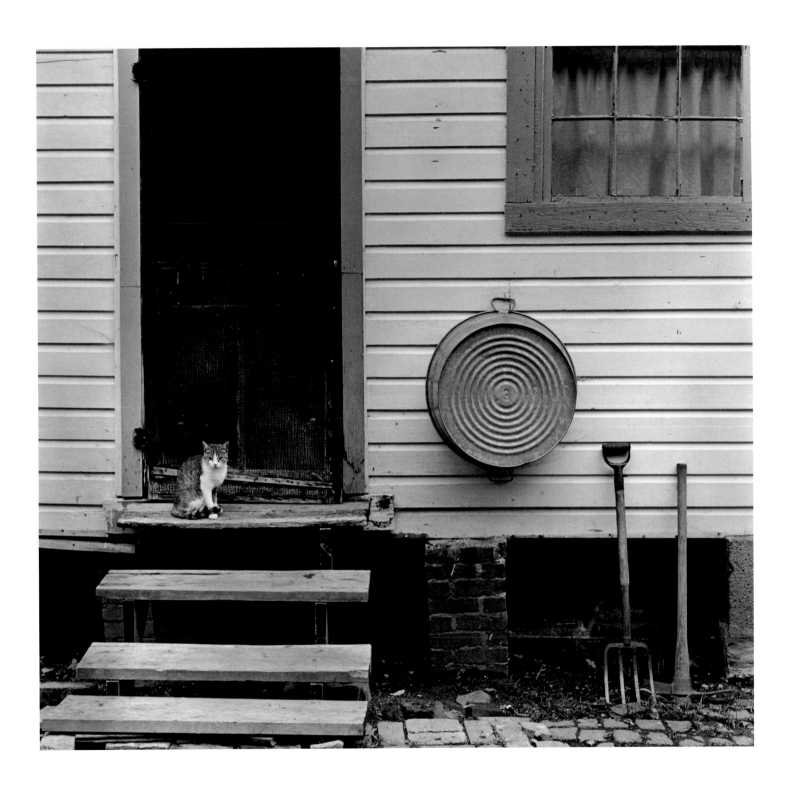

17 · Lidge Hunter's House

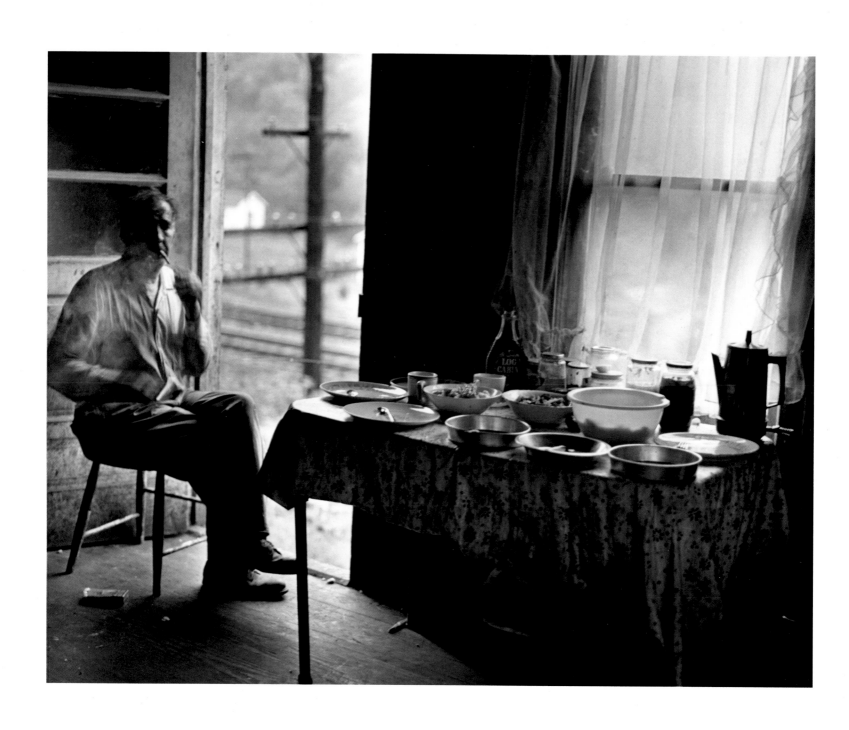

18 · William Marcum

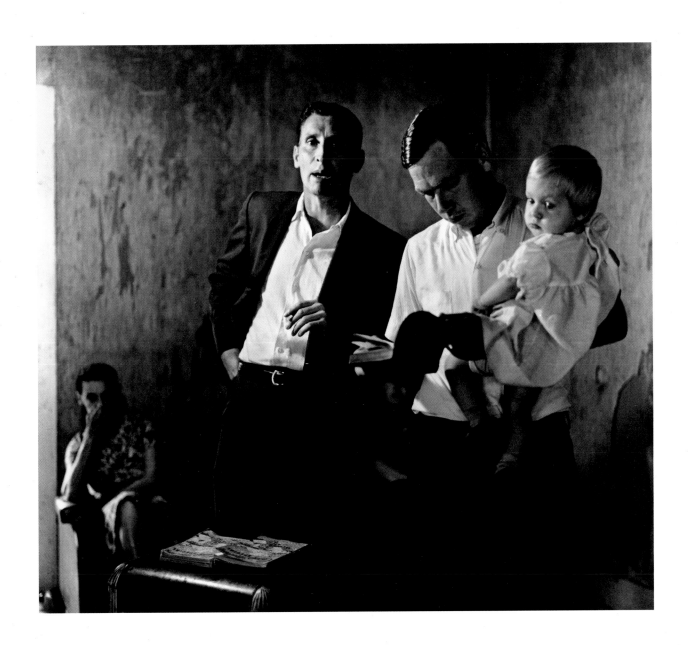

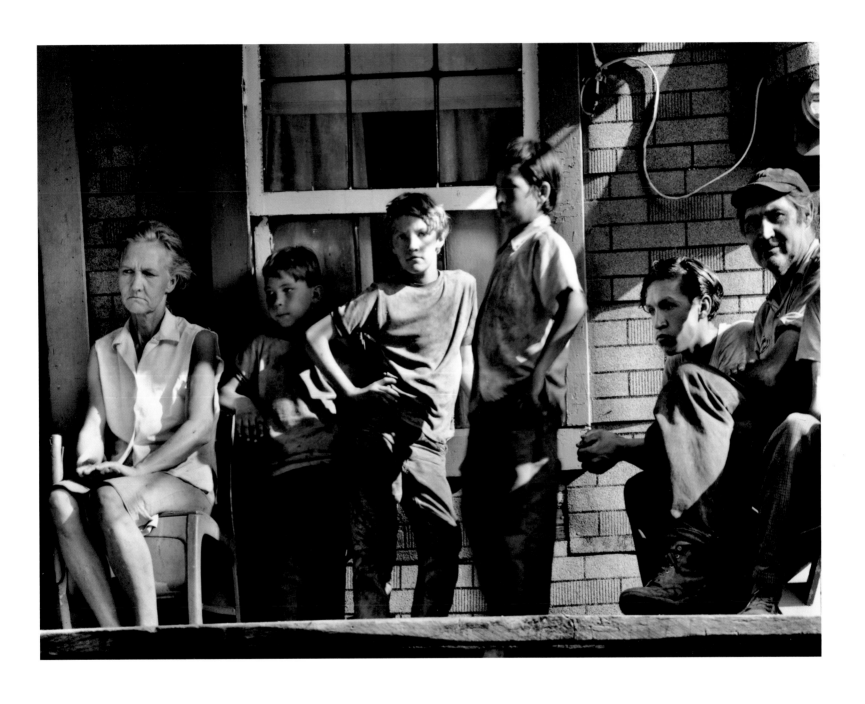

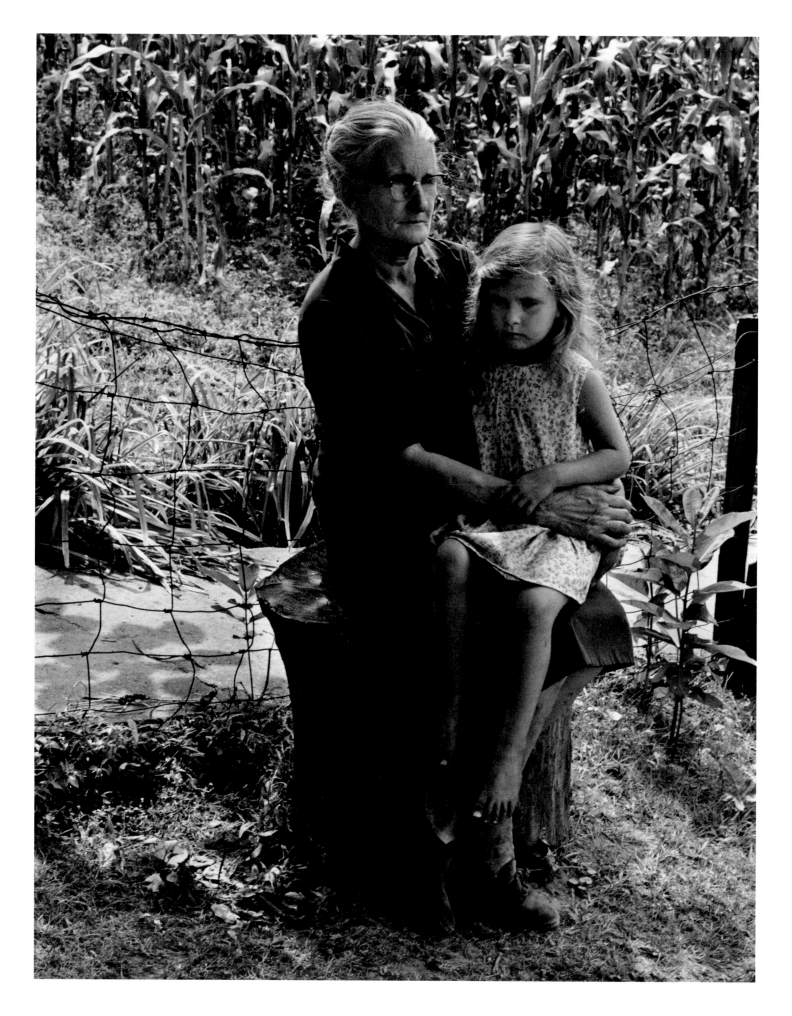

21 · Mae Phillips and Granddaughter Jeanie

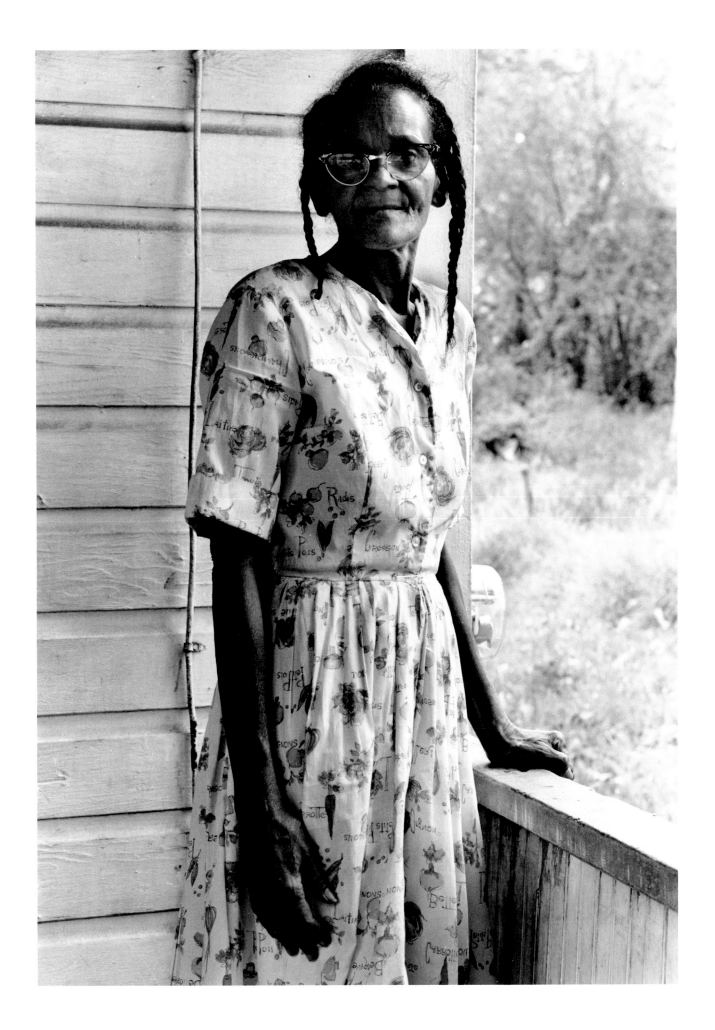

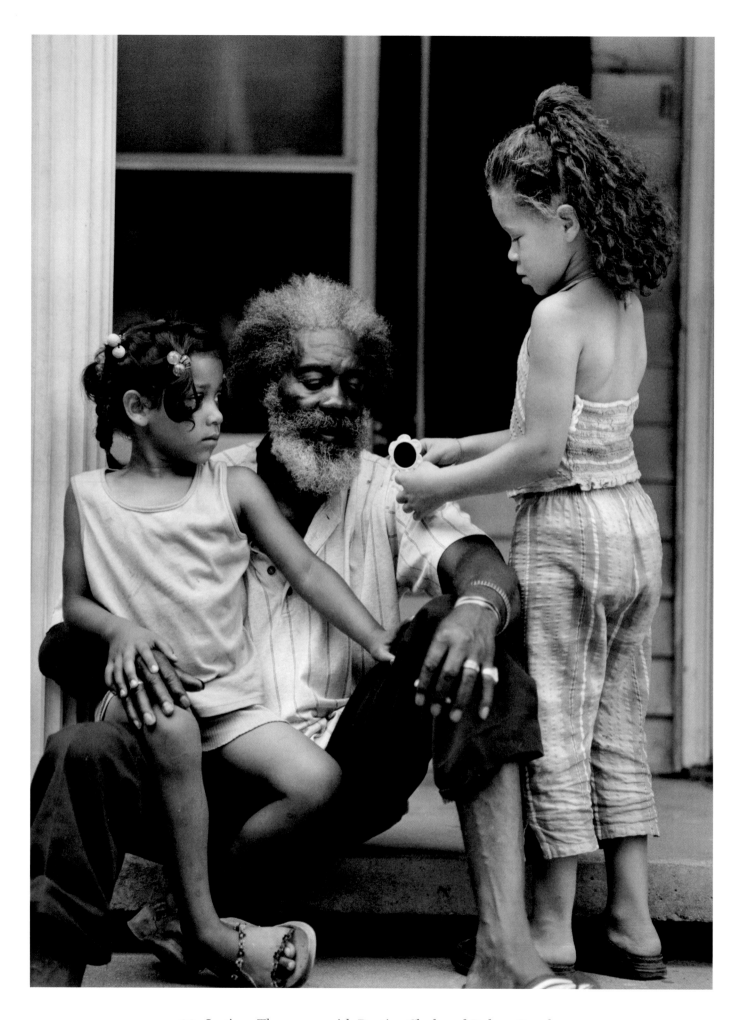

23 · Lucious Thompson with Destiny Clark and Delena Brooks

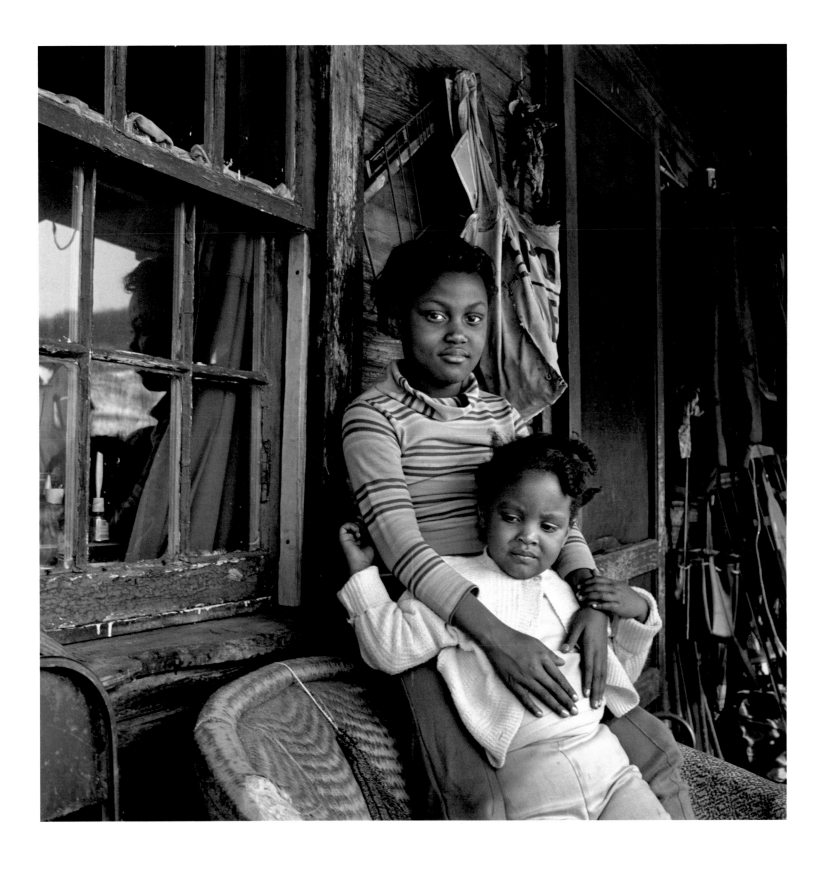

25 *Donna Muncy,* Crum, Wayne County, West Virginia, 1970. In 1968, on my first trip to southern West Virginia, I was introduced to the Muncy family by a VISTA volunteer who was working with them. Two years later I made an Easter-week road trip through West Virginia and Kentucky, including an overnight stay with the Muncy family. Donna (now Donna Hicks), who was ten years old in the photo, still lives in the county.

26 *Glenda Lee,* Pikeville, Pike County, Kentucky, 1970.

27 *Oglesby Bedroom,* Stotesbury, Raleigh County, West Virginia, 1982. It was Sunday morning, Memorial Day weekend. While I was photographing in the black section of Stotesbury, a car approached and the driver asked what I was doing. When I explained that I was making photographs about the life of the Appalachian coal miner, he said, "Well, why don't you visit Luther Oglesby; he's a coal miner and lives just around the bend." Luther Oglesby was standing outside his front door as I arrived and, after hearing my brief explanation of my project, invited me in. Following introductions to family members, Mr. Oglesby and his oldest son sat with me at the dining room table and offered me homebrew. Luther talked about his work. He had worked in the mines for forty-four years, the last several as a roof bolter. On Monday of the first week in April 1982, a notice had been posted at his mine: "No More Work Till Further Notice." He "worked that day and didn't work no more." He turned sixty that May. After about an hour, Luther asked, "What do you want to photograph?" I said, "I don't know, let's see," and he proceeded to walk me around the house. When I entered a small bedroom with traditional wallpaper, an antique mirror and bed, and children's crayons, I knew I had to photograph it. With my medium-format camera on my tripod, I composed, focused, and then hesitated, feeling that I needed something more in the picture. Just then, Dora Antoinette, the Oglesbys' daughter, walked into the doorway.

28 *Osage Window,* Scotts Run, Monongalia County, West Virginia, 1970. The unincorporated town of Osage and several other communities in Scotts Run were displaced by Interstate 79 in 1974. Scotts Run is a five-mile-long hollow named after the winding stream that flows through it. Even before the turn of the twentieth century, coal was being mined there, and by the early 1920s Scotts Run had become one of the most productive areas in Appalachia. It was also a hotbed of miner union organizing and intense strikes. With a population that was multiracial and multiethnic, it was among the hardest hit by the Depression and experienced severe poverty. First Lady Eleanor Roosevelt visited impoverished miners' families there in 1933. Among others visiting in the 1930s were the photographers Lewis Hine, Walker Evans, and Ben Shahn.

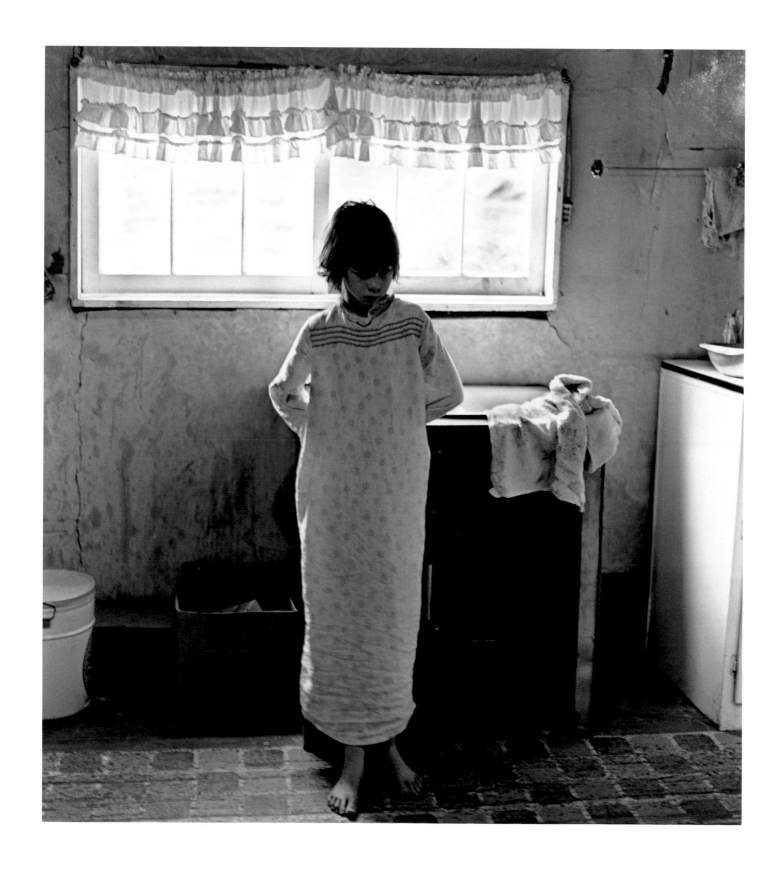

25 · Donna Muncy

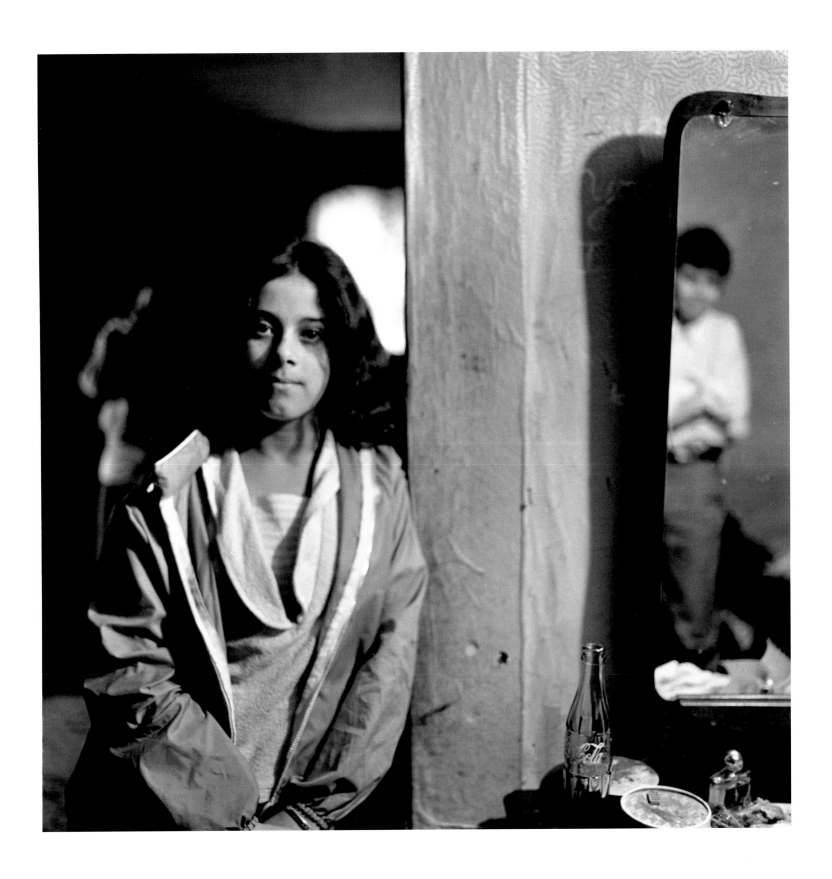

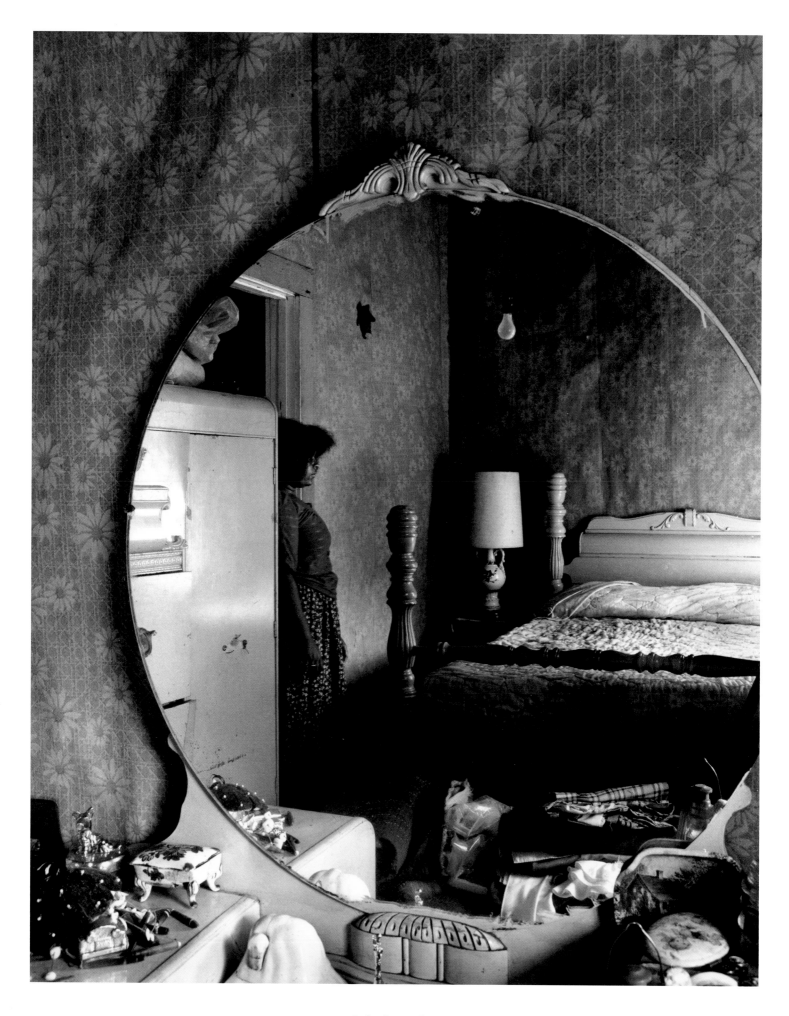

27 · Oglesby Bedroom

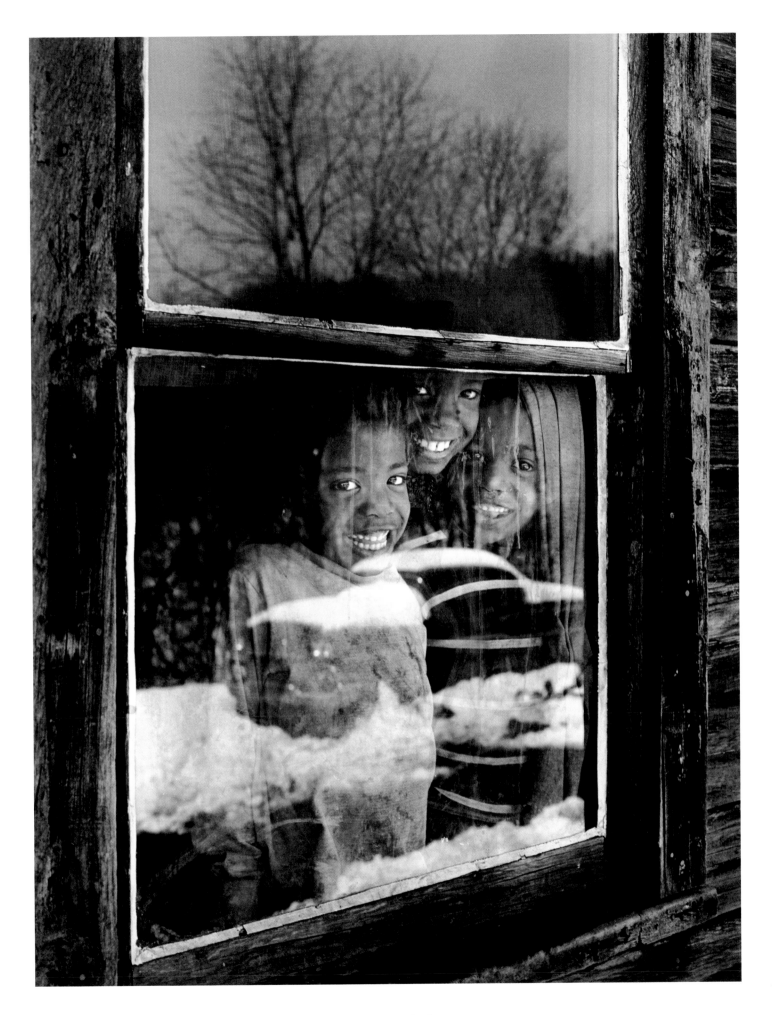

28 · Osage Window

29 *Nimrod Workman,* Chattaroy, Mingo County, West Virginia, 1972. I met Nimrod in Delbarton, where he was hanging out with union organizers and other older retired miners. They were among those who, in response to the death of seventy-eight miners in the Consol No. 9 Mine methane explosion in Farmington, West Virginia, on November 20, 1968, had participated in region-wide strikes demanding a national mine safety and health act. Nimrod lived on School Street, where his closest neighbors were African American miners. He was named after his grandfather, a Cherokee Indian. Born in 1895 in Martin County, Kentucky, he became a miner at the age of fourteen, in Mingo County, West Virginia, where he mined coal for forty-two years. He retired because of black lung disease and a slipped disc. Engaged in union organizing struggles from an early age, he worked alongside Mary Harris "Mother" Jones in West Virginia in 1920 and 1921, and participated in the Battle of Blair Mountain. In later years, as an advocate for black lung victims, he wrote, sang, and recorded songs about his life as a miner. He appeared in the funeral scene of the film *Coal Miner's Daughter* (1980), which also featured his daughter Phyllis Boyens as Loretta Lynn's mother, singing "Amazing Grace." When I asked Nimrod if he had a room to rent, he said he didn't but thought his friend and neighbor George Johnson might. That's how Alice and I ended up living with the Johnson family in Chattaroy during the summers of 1971 and 1972. One evening, Nimrod came over to the Johnson's porch where they sang a few songs including "Amazing Grace" and "When the Saints Go Marching In." Then Nimrod sang one of his own songs alone, "Coal Black Miner Blues." He died in 1994.

30 *Adrienne Moore,* Clear Fork, Wyoming County, West Virginia, 2008. Adrienne Moore, a ninth grader at West Side High School, was at the girls' softball team practice.

31 *Shelby Mari Hagan,* Dixie, Nicholas County, West Virginia, 2008. "What are you doing?" I asked Shelby during a visit to the preschool/kindergarten of Dixie Elementary School. "I'm feeding the baby because it's hungry." The principal told me that Shelby, along with most of the children in her school, qualified for the free lunch program.

32 *Nathan Coleman,* McDowell County, West Virginia, 2004. I visited Bartley Elementary's first grade class on the first day of school. In June 2005, the small, old, community-based school was permanently closed. Although mountaintop removal mining, timbering, and underground mining in McDowell County are producing great wealth, most of the money leaves the county and state. McDowell remains one of the poorest counties in the entire nation.

33 *Bartley Elementary School Yard,* McDowell County, West Virginia, 2003.

34 *Delisia Clark and Delena Brooks,* Tom Biggs Hollow, McRoberts, Letcher County, Kentucky, 2002.

35 *Mark Cullum* at Abandoned Tipple, near Hickory, Washington County, Pennsylvania, 1973.

36 *Alysa Estep,* Litton Hollow, Chattaroy, Mingo County, West Virginia, June 12, 2004. On May 30, the waters of a flash flood had ripped up the creek culvert, taking out part of a chain-link fence and flooding the trailer behind Alysa's grandfather's house. While she hopped over debris dragged down the mountain by the flood into the now-dry creek bed, Alysa's grandfather, James Gauze, talked to me about the timbering three hundred feet up the mountain at the top of the holler: "For about a year, they've been hauling out five to six truckloads of logs a day." His wife and Alysa's grandmother, Edna Gauze, worried that if they got heavy rains again the flooding could be even worse: "Nothing left to hold the water on the mountains, nowhere for the water to go."

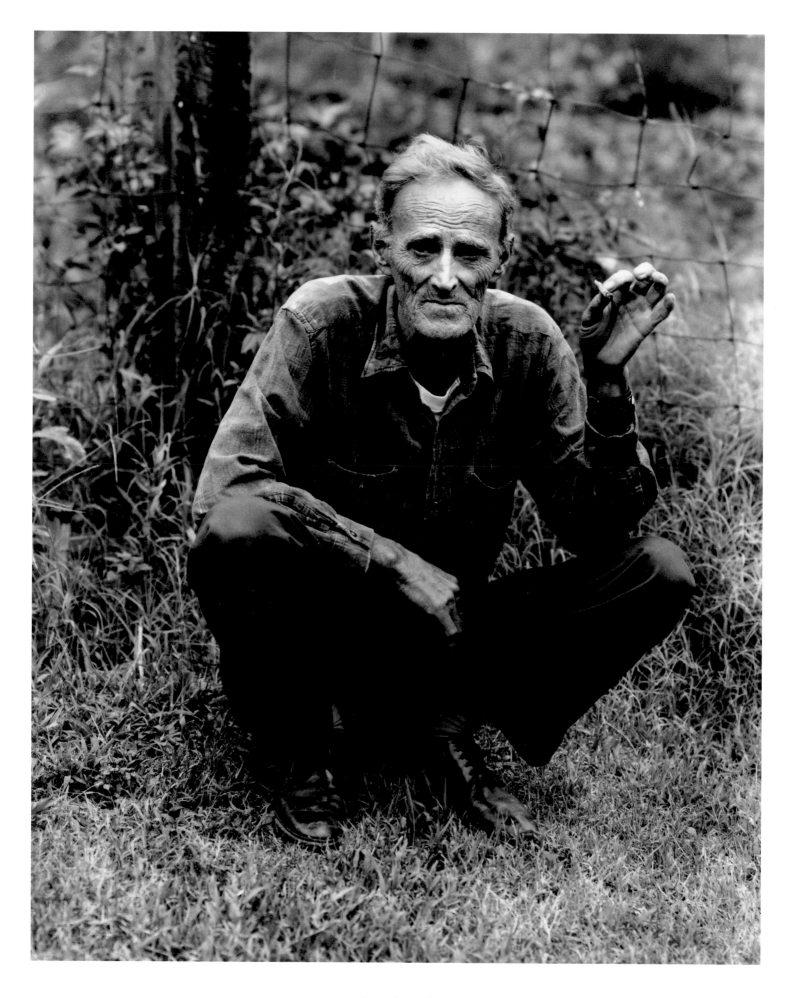

29 · Nimrod Workman

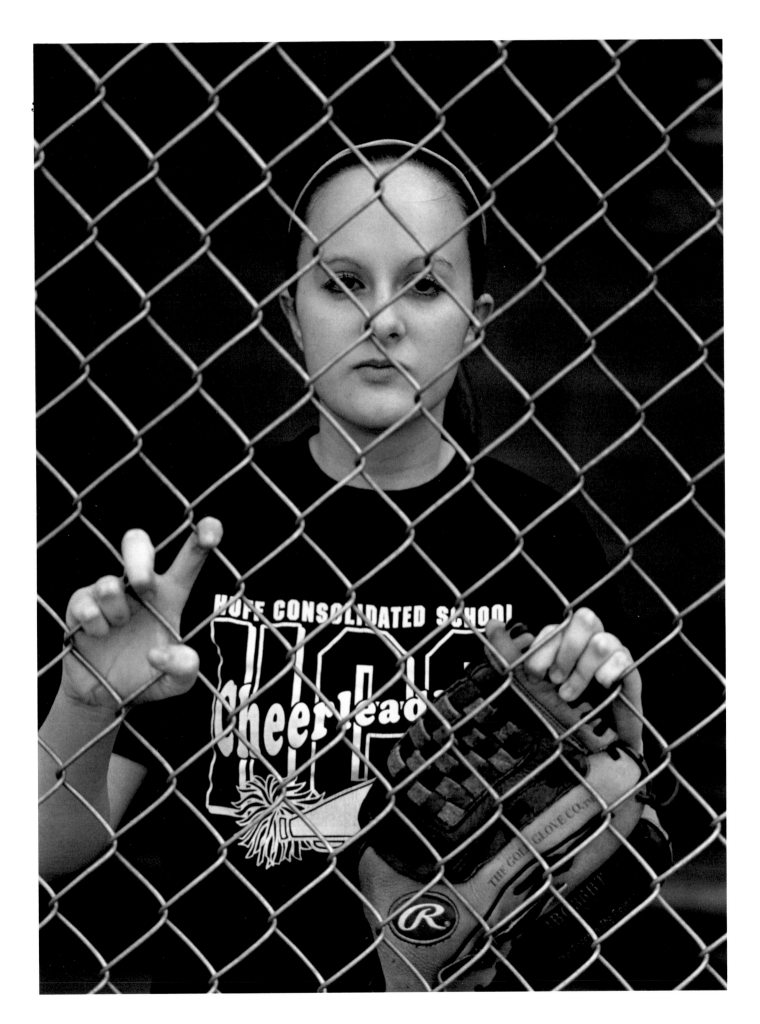

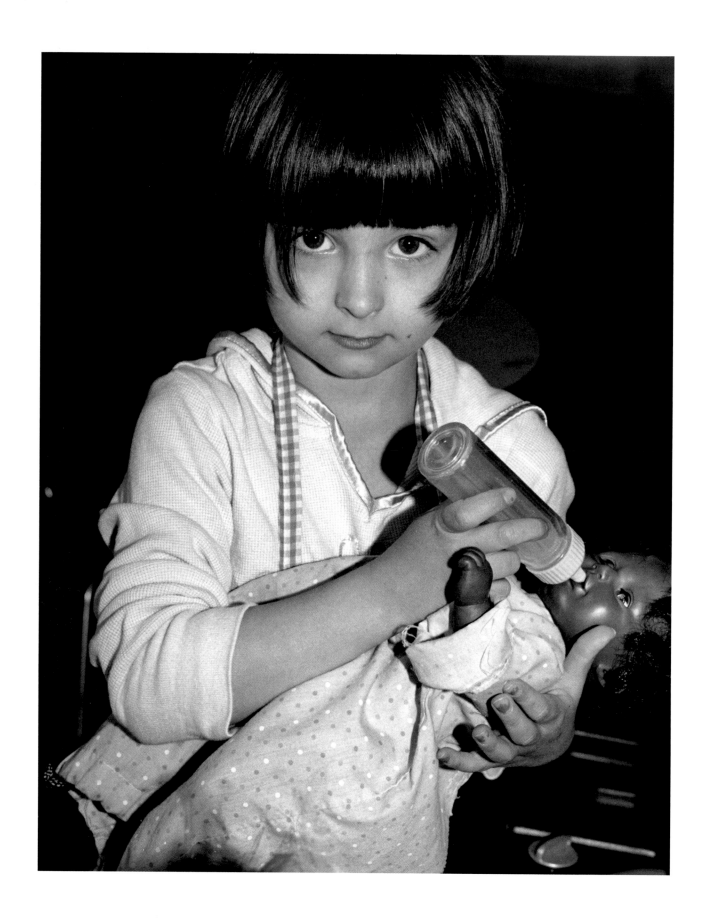

31 · Shelby Mari Hagan

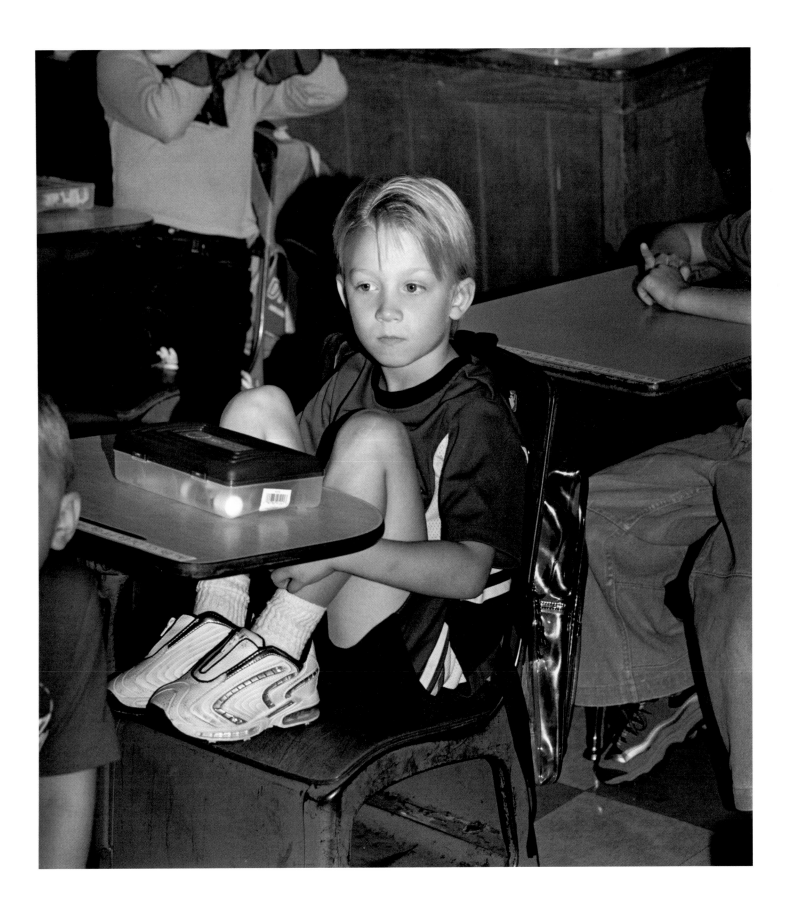

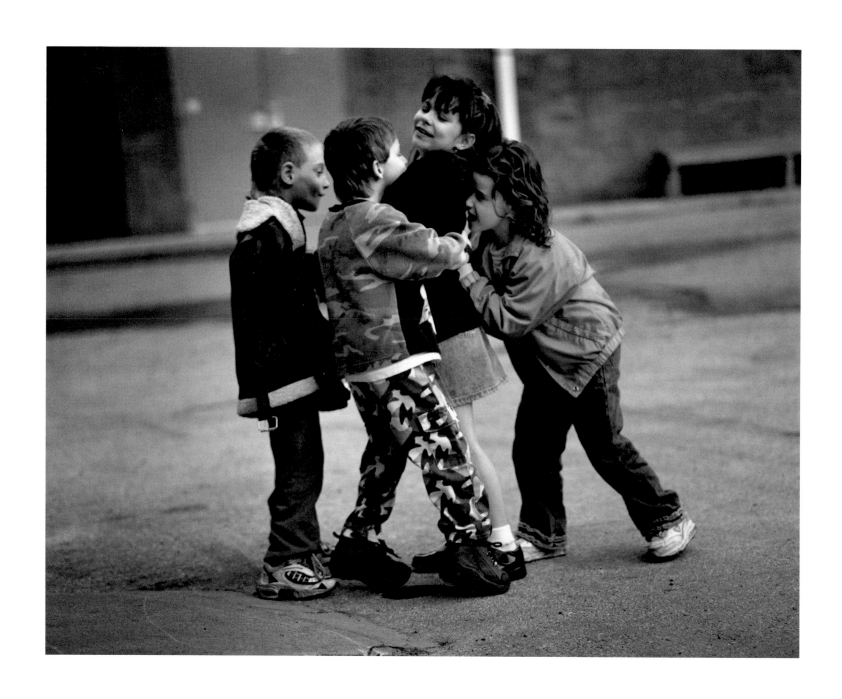

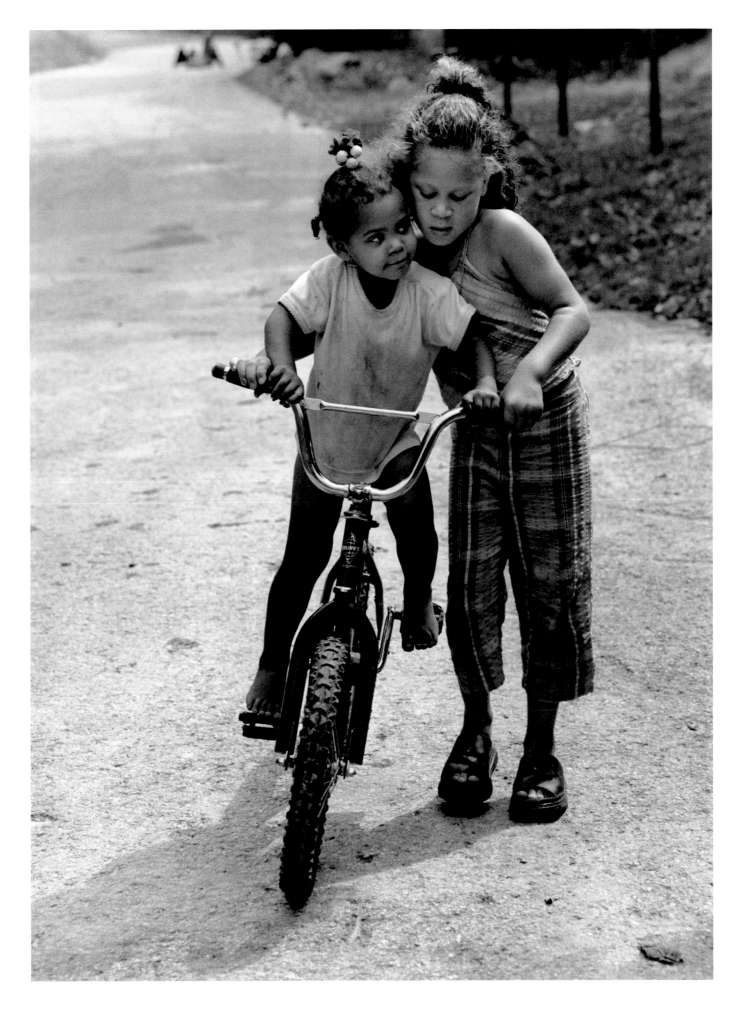

34 · Delisia Clark and Delena Brooks

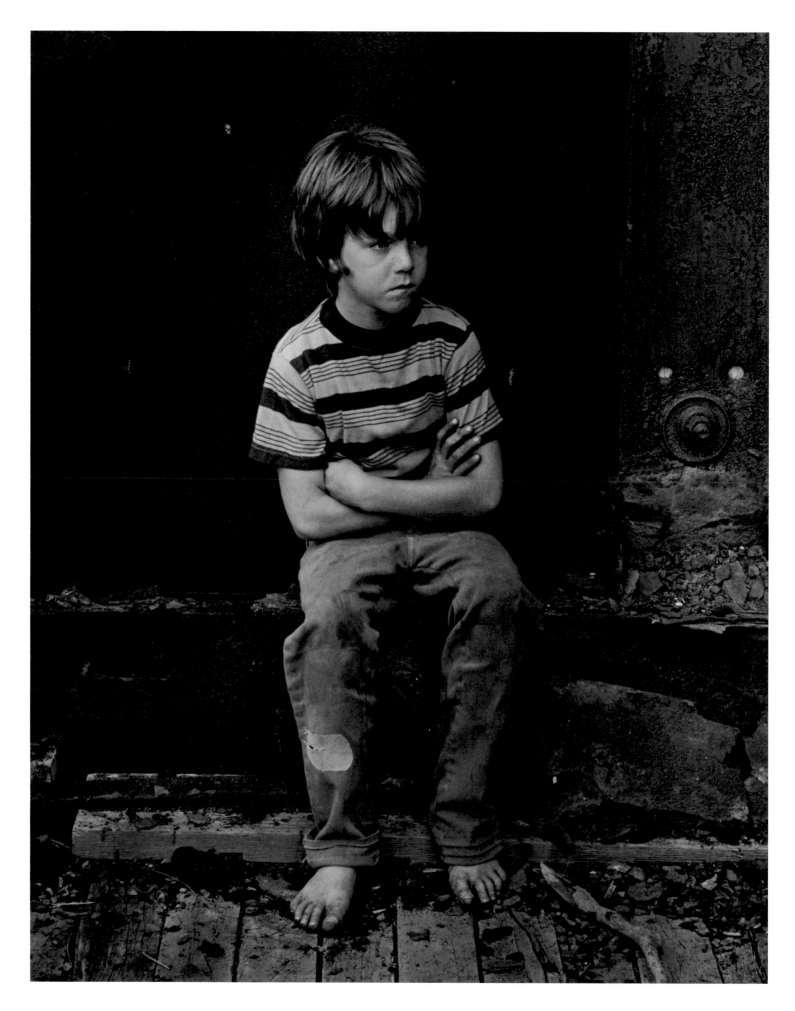

35 · Mark Cullum

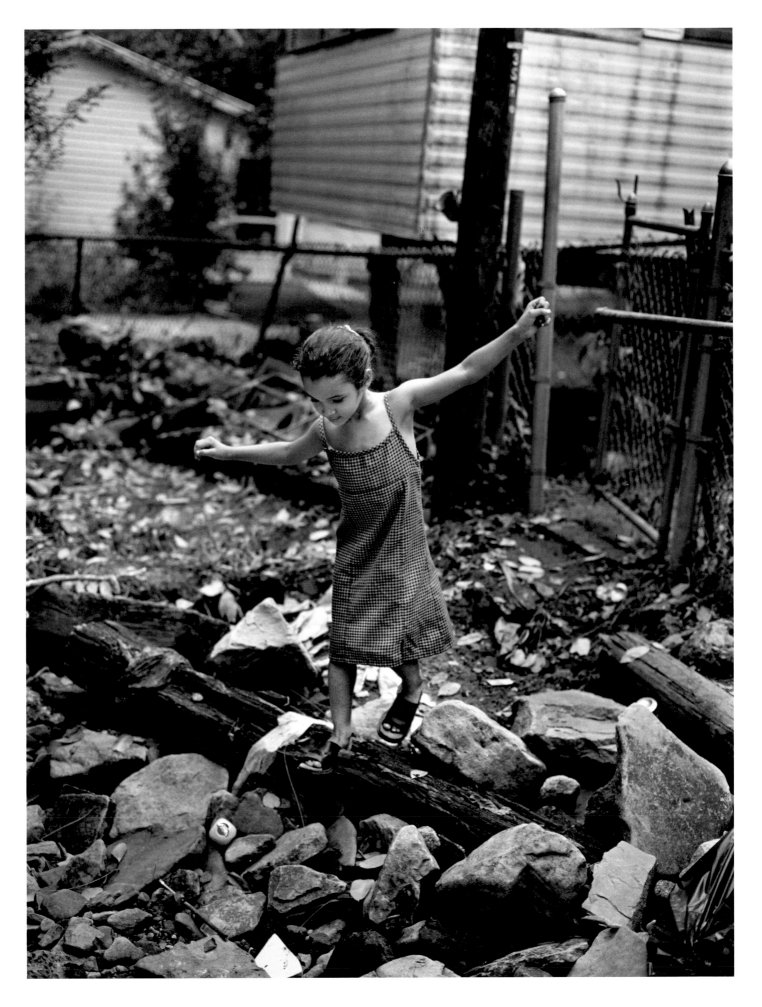

AT THE MINES

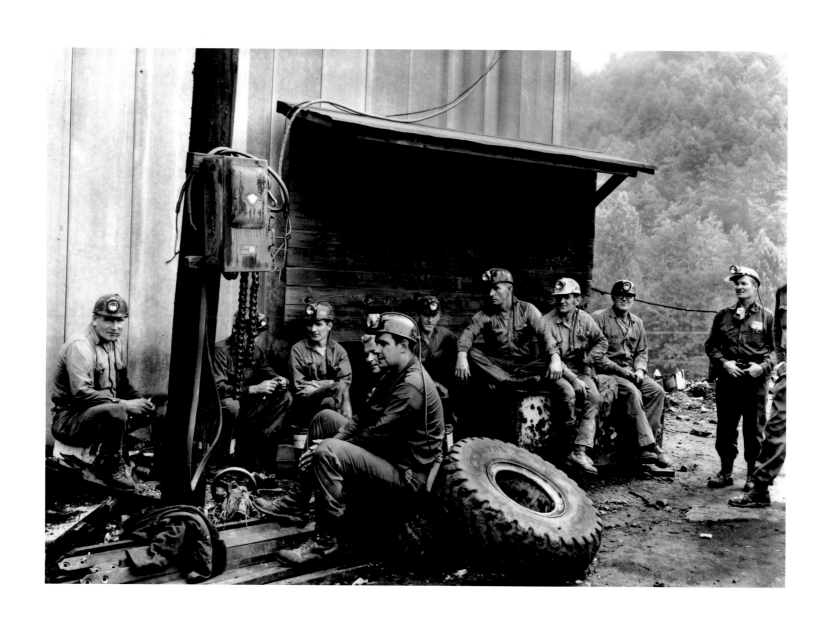

37 *Waiting and Whittling,* Eastern Coal Company, Stone, Pike County, Kentucky, 1970. This mine, owned by Pittston, was the first one I photographed. I approached the miners and asked if I could take their picture. "Why?" "I want to make photographs of the real life of the coal miner to show back in New York City where I am a schoolteacher." A foreman jokingly asked, "You're not one of those 'Nader's Raiders' are you?" Most often, I used a medium-format hand-held camera, but occasionally, as for this photograph, I used my larger format, 5 × 7 Deardorff view camera, made of mahogany and metal, with a black bellows, mounting it on a tripod and focusing under a black cloth. While I was setting up the camera, one of the older men said to me, "A miner's life is a dog's life! Buddy, put that in your book!" After several visits to the mine site before the morning and afternoon shifts, I drove back to New York, developed my film, made contact prints in duplicate, and came back a week or so later with a set of prints to give to the men.

38 *Miners, Coal Cars, and Preparation Plant,* Sycamore Mining Company, Cinderella, Mingo County, West Virginia, 1971. I was walking around looking for a good vantage point, when, behind the miners and the coal cars, the preparation plant was momentarily transformed into a geometric abstraction. Built of steel, gritty and full of noise, the preparation plant is where the extracted coal, carried from the mine by conveyor and/or coal cars, is separated from slate and soil, washed and cleaned with water and toxic organic chemicals. The coal is then stored in silos or outdoor piles before being loaded into railroad coal cars, trucks, or barges destined for power plants and steel mills in eastern United States. Increasingly, Appalachian coal is shipped overseas. The toxic liquid waste is usually pumped to coal slurry reservoirs, often on top of worked-out sections of mountaintop removal mines. There it will remain for years, slowly seeping into the groundwater and leaking into streams, creeks, and rivers

39 *Two Miners,* Sycamore Mining Company, Cinderella, Mingo County, West Virginia, 1971.

40 *Cecil Perkins,* East Williamson, Mingo County, West Virginia, 1970. A few minutes after I photographed Cecil Perkins, his friend drove up and they rode off together to the mine in Kentucky where they worked. With their permission, I followed. Had they not slowed down several times for me, I would have lost them, and probably never made photographs at that Eastern Coal Company mine.

41 *Tipple Man,* Eastern Coal Company, Stone, Pike County, Kentucky, 1970. Although his job at this mine was outside, working at the loading tipple, he faced the hazard of being periodically exposed to clouds of coal dust.

42 *Kneeling Miner,* Wolf Creek Colliery, Lovely, Martin County, Kentucky, 1971.

43 *Toby Moore,* Old House Branch Mine, Eastern Coal Company, Pike County, Kentucky, 1970. After I had returned several times to photograph before the shift changes, the safety foreman asked if I would like to photograph inside the mine. "Yes," I said, but told him I didn't have a flash. He offered to provide light. A couple of days later he and the chief electrician took me underground. I stopped a black miner walking by during his lunch break and asked if I could take his photograph. My escorts held up five 300-watt light bulbs on an electric cable, which they jacked into the mine power line to illuminate the man's face. I never got his name. More than thirty years later, when I returned to Chattaroy, Mingo County, West Virginia, where I had spent the summers of 1971 and 1972, I showed my book *Images of Appalachian Coalfields* to Thomas Allen, also an African American and one of the few people I had known who was still living in Chattaroy. The photograph, he said, was of his good friend and work buddy Toby Moore, who had since passed away. Mr. Moore had convinced him to retire from the mines while he could still enjoy life.

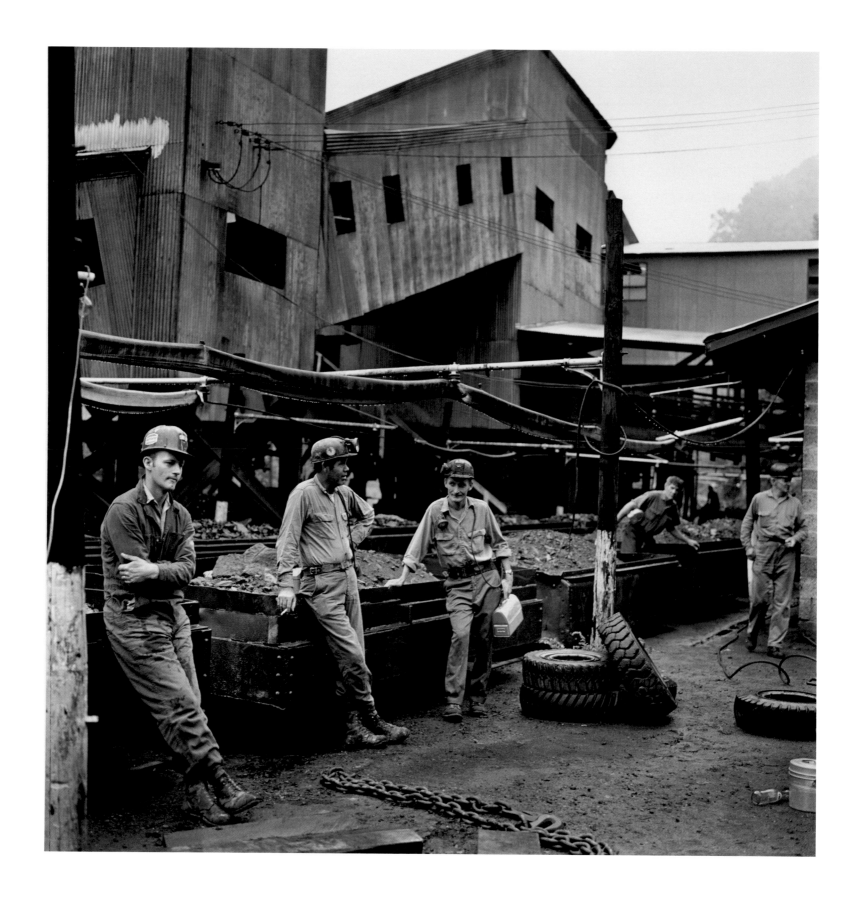

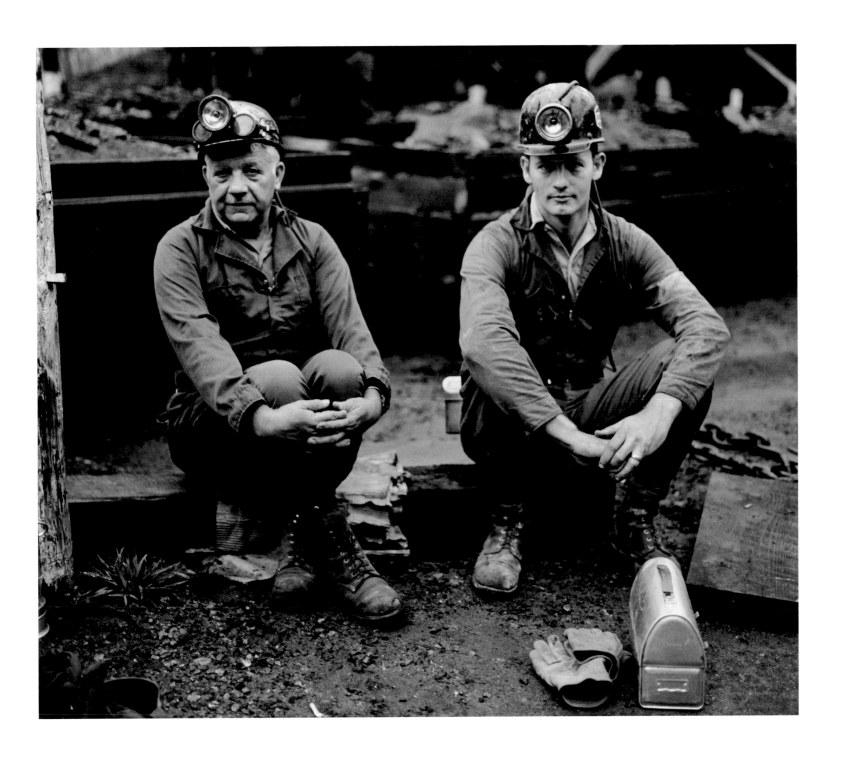

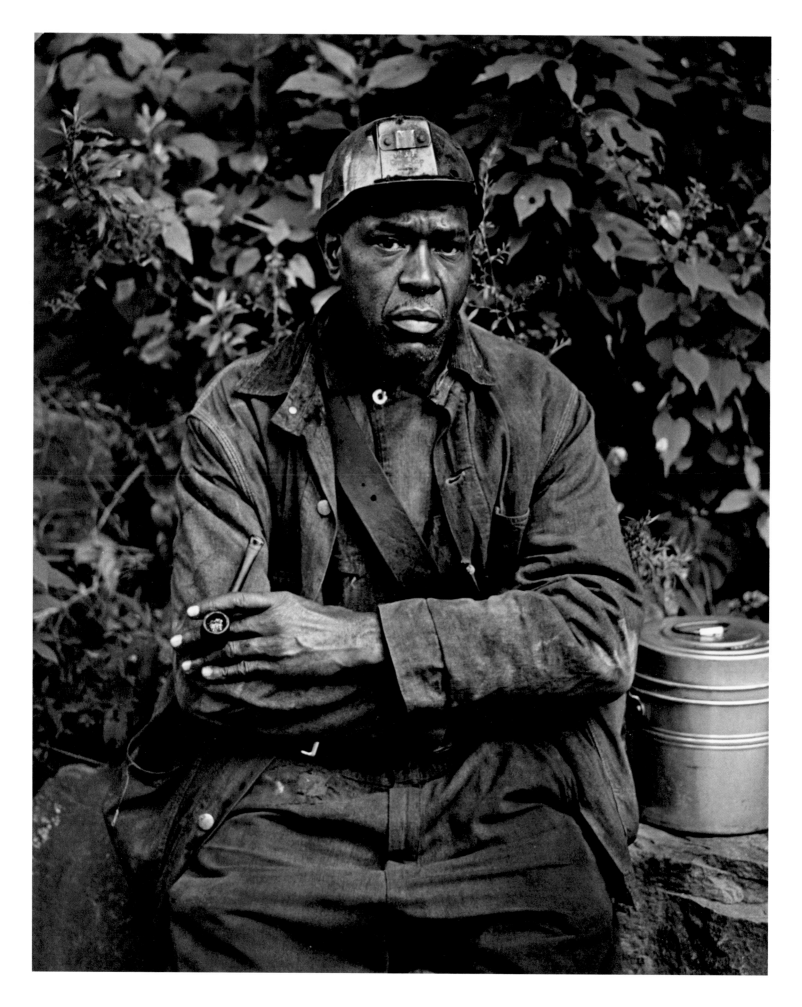

40 · Cecil Perkins

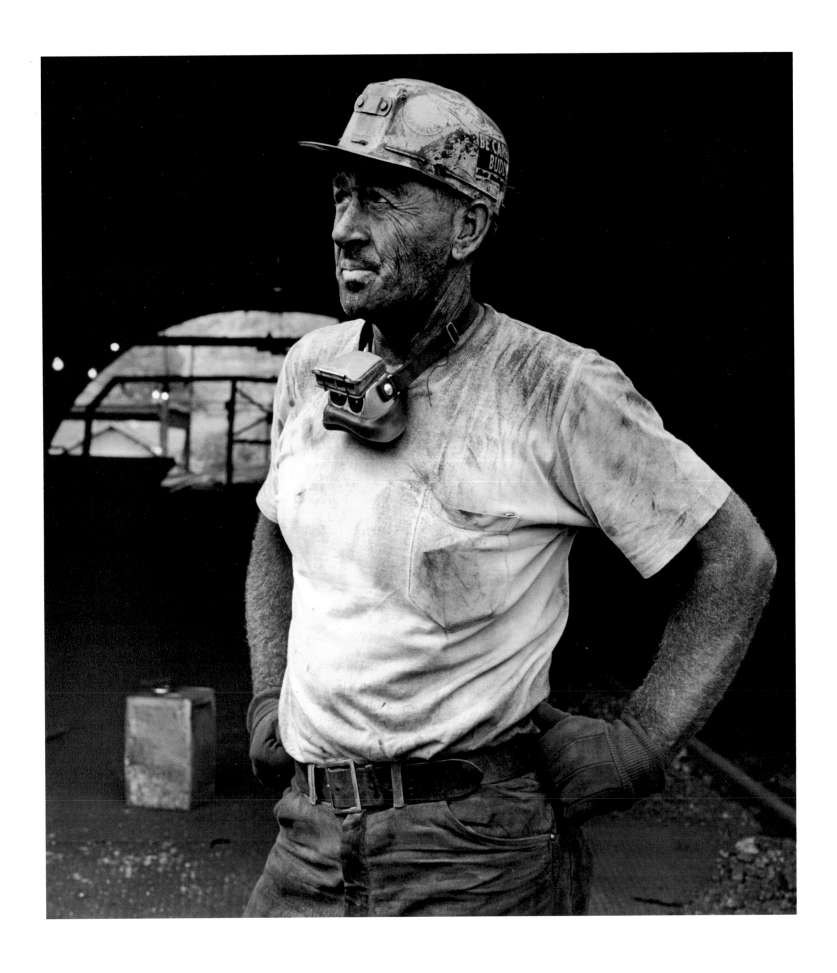

41 · Tipple Man

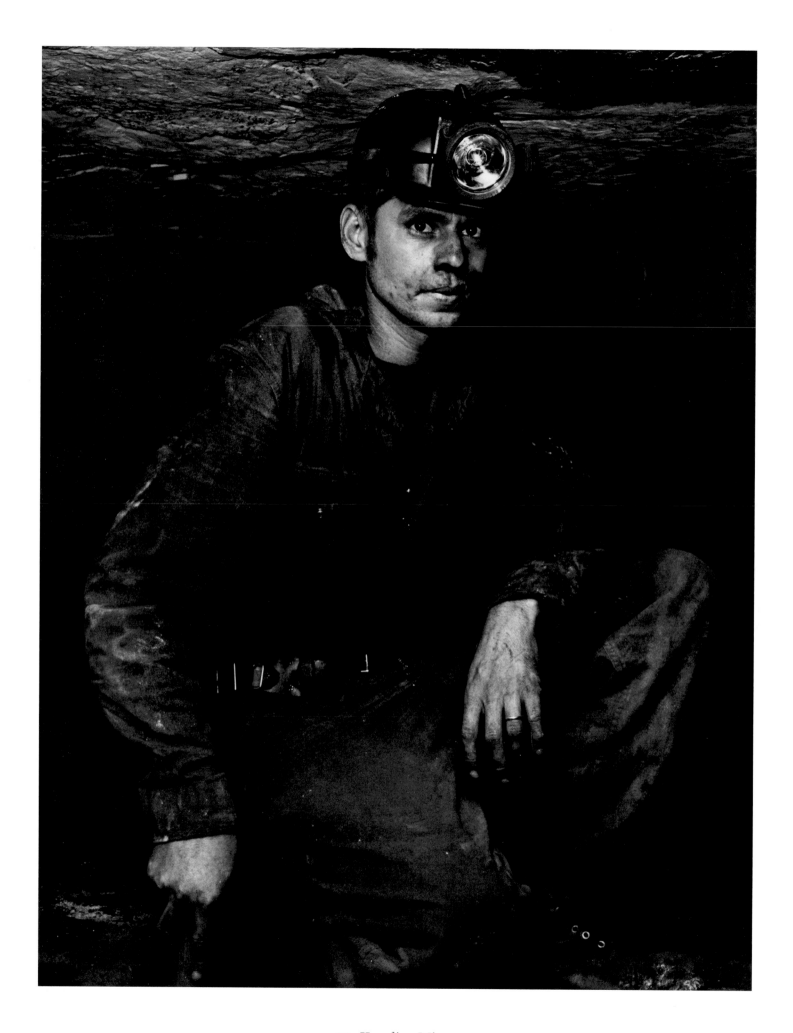

42 · Kneeling Miner

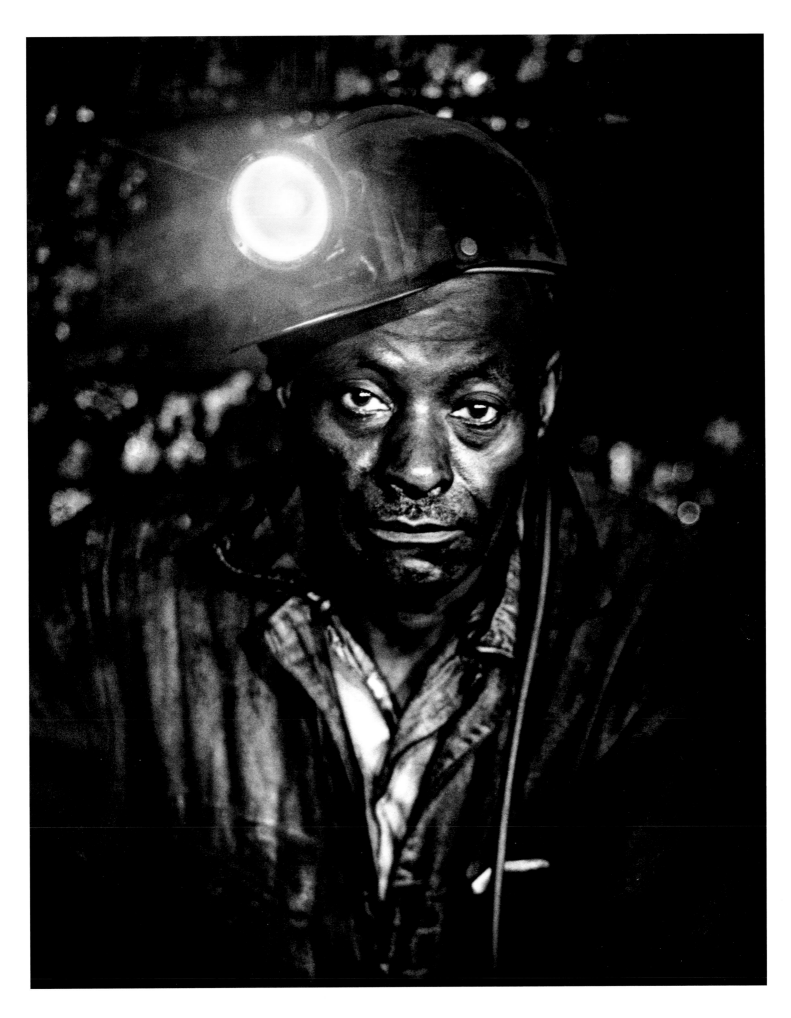

43 · Toby Moore

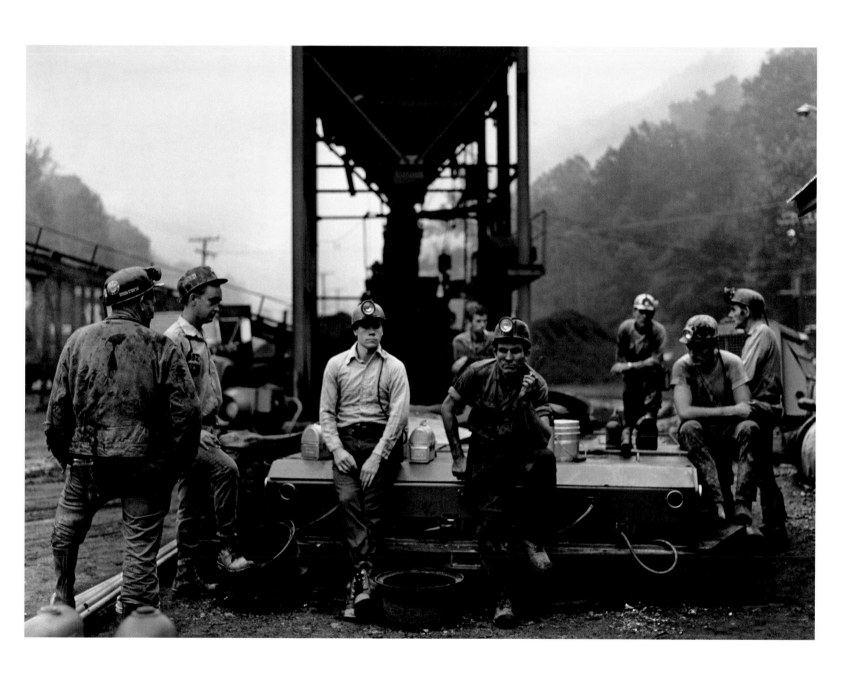

44 *Smith Brothers Mining Company,* Williamson, Mingo County, West Virginia, 1971. B.L. Farley, the young man in the light shirt, lived in the same coal camp community where I was renting a room. One afternoon, while I was photographing and playing horseshoes with some of the people there, B.L. asked me why I was photographing. When I explained, he asked, "Why don't you come to the mine where I work?"

45 *Roof Bolter,* Federal No. 2, Mine, Eastern Associated Coal Corporation, Grant Town, Marion County, West Virginia, 1982. The most dangerous job in a mine is roof bolting. Roof bolters go into a new section and reinforce the ceiling by installing long steel bolts and epoxy resin to bind several strata of rock. This is a critical step, a precaution taken before other workers and machines can enter the area. Even with the improved technology of roof bolting, roof falls still remain the most frequent cause of injury and death in the mines. Previously, timbers had been used as pillars to reinforce and hold up the roof; when the roof was about to collapse, miners could hear the timbers crack and often had time to escape. Roof bolting makes it possible to create large spaces without pillars where machines called continuous miners can operate, but it gives no warning when a ceiling is about to fall.

46 *Preparing to Shoot the Coal,* Wolf Creek Colliery, Lovely, Martin County, Kentucky, 1971. To loosen the coal from the face, holes are drilled and filled with sticks of blasting powder, which are then detonated—a process called shooting the coal. Rather than blasting, however, most mines use a continuous miner and, if the mine is big enough, a longwall to cut the coal at the face.

47 *Janice Martin,* Doubletake Mine, Big Creek, McDowell County, West Virginia, 2002. Martin is the only female and one of only two black state mine inspectors in West Virginia. After working as an underground coal miner for nine years and getting laid off, she studied mine engineering, switched to construction engineering, and received an associate degree at Bluefield State College. She then drove an eighteen-wheel tractor-trailer truck cross country for three years before becoming a state underground mine inspector, a position she has held since 1991. She is now the senior inspector in the Welsh Office. She lives in Jenkinjones, McDowell County, with her daughter Jazzlee, who attends Montcalm High School in Mercer County.

48 *John Harrison and Willie Belvin Drilling Blastholes,* Bevin and Fauch Mine, Martin County, Kentucky, 1971.

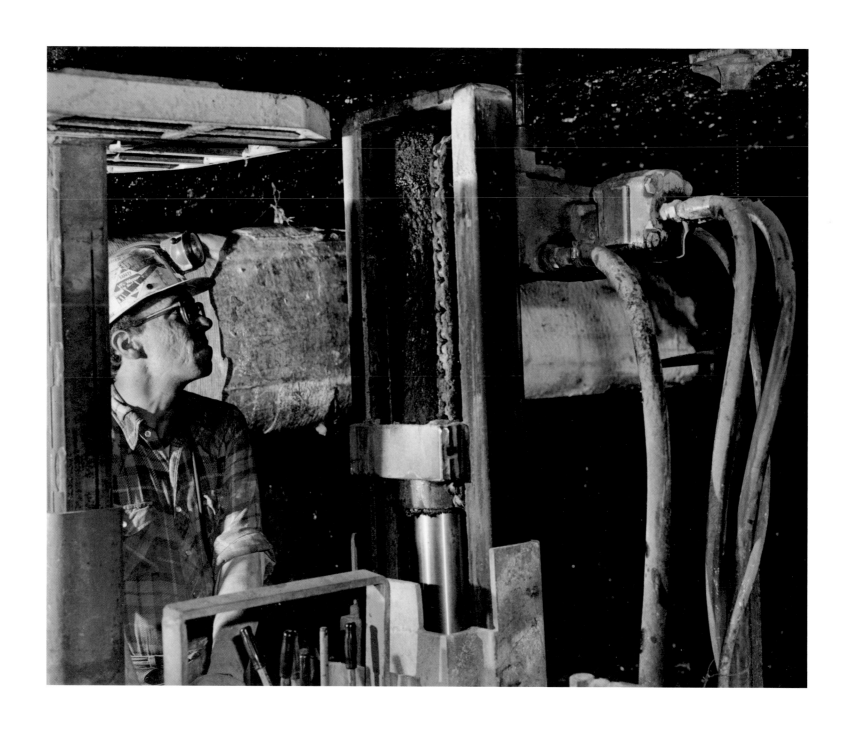

45 · Roof Bolter

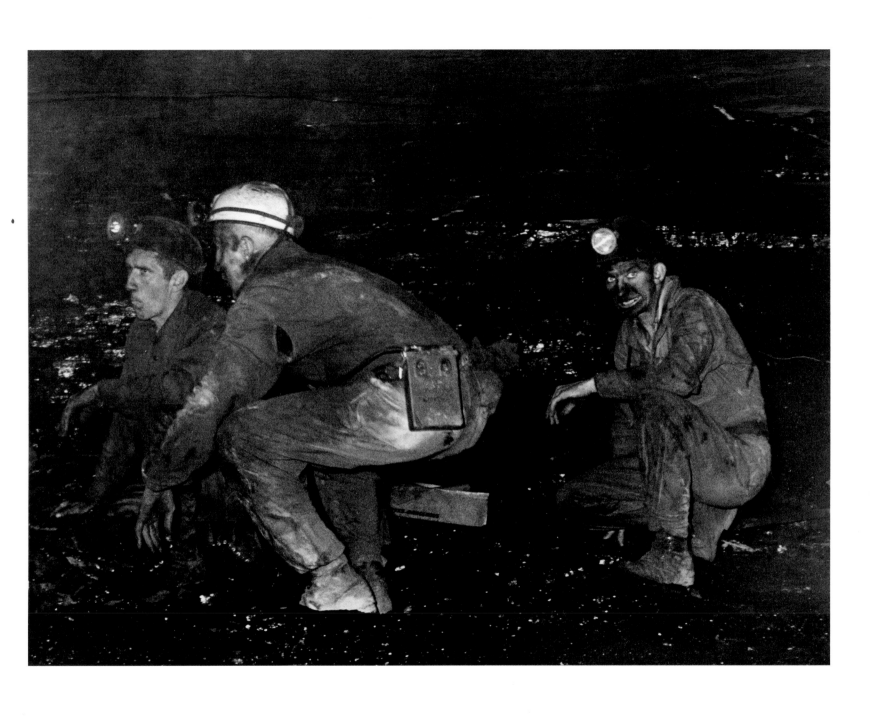

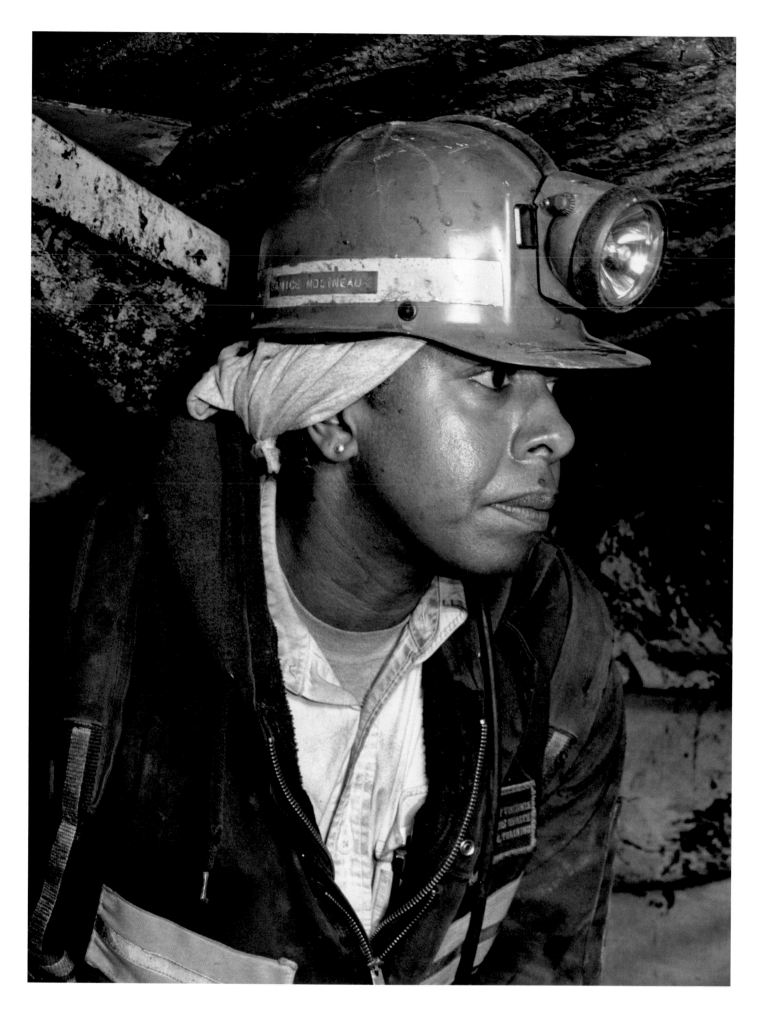

47 · Janice Martin

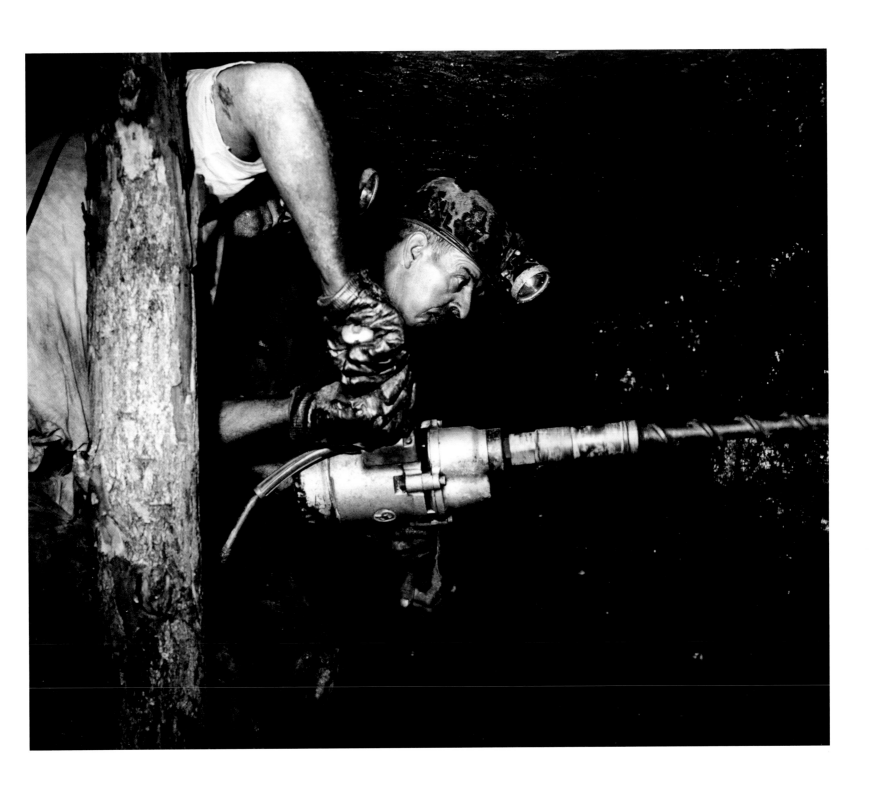

48 · John Harrison and Willie Blevin Drilling Blastholes

49 *Andrew Kosto,* Sycamore Mining Company, Cinderella, Mingo County, West Virginia, 1971. As I was talking and shooting with my hand-held camera among the miners waiting for their shift to begin, the face of an older man working around the dusty, noisy loading tipple caught my eye. When I asked about his unusual miner's cap, he explained it was an old 1932 "turtle shell." He agreed to let me make a portrait of him with my big camera. While I focused my 5 × 7 Deardorff under the black cloth and made several slow exposures, some of the other miners watched and joked, but Kosto remained stoic and still. Mantrip cars carrying workers in and out of the mine rumbled along tracks within a couple of feet on either side of us. Several years later, I learned that Andrew Kosto had been killed by a large piece of slate that fell as he was trying to locate an obstruction under the loading tipple.

50 *Brenda Ward,* U.S. Steel No. 50 Mine, Pinnacle, Wyoming County, West Virginia, 1982. I had heard that many women worked there. Women entered the mines in large numbers in 1973, adding a higher level of safety consciousness to the workforce and helping mine workers win the contractual right for new-parent leave. In 2002, in order to get permission to photograph in the schools, I showed my book *Images of Appalachian Coalfields* to the assistant superintendent of schools of McDowell County. When she saw this image, she said, "I know Brenda Ward. Her son went to high school with mine."

51 *End of Shift,* Wolf Creek Colliery, Lovely, Martin County, Kentucky, 1971. From my previous visits to this mine, I knew when, where, and how the men would emerge. I set up my 5 × 7 Deardorff view camera, focused, cocked the shutter, and waited.

52 *Going Home,* Kayford Branch Mine, Bethlehem Mining Company, Cabin Creek, Kanawha County, West Virginia, 1978. I received the following e-mail in 2011 from a man in Michigan, relating to this photograph: "I lost an uncle 4/5/2010 in a coal mine explosion [in which twenty-nine miners died at Upper Big Branch Mine] in Montcoal WV. Today I was surfing the net looking at coal mining photos when I came across a picture. It appears you took the picture of some miners leaving a coal mine. The foreperson in the photo looks like my Grandpa. His name was Hazel Preston Brock. He died in 1986 and was the father of my uncle who died last year at Montcoal. My grandfather was a great man; hard worker, quiet and would give you the shirt off his back, if you needed it! He died a mine foreman. My grandfather would be so excited to know I found this picture!! I was his first grandson; me and him were big 'buddies'!"

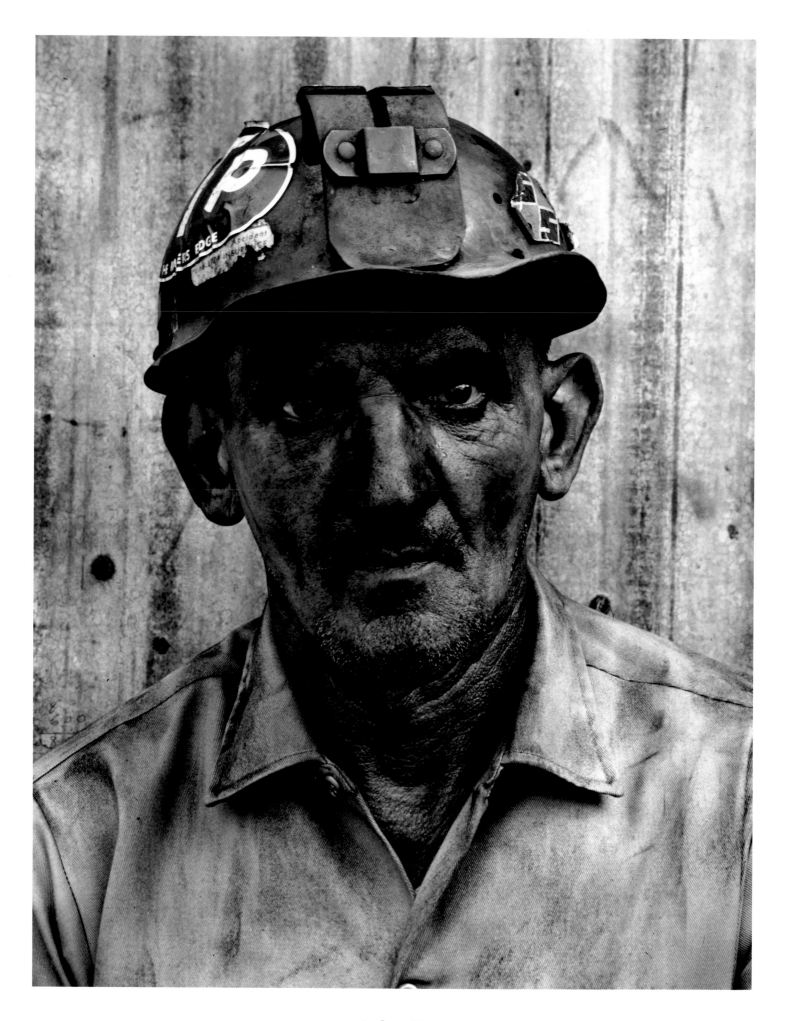

49 · Andrew Kosto

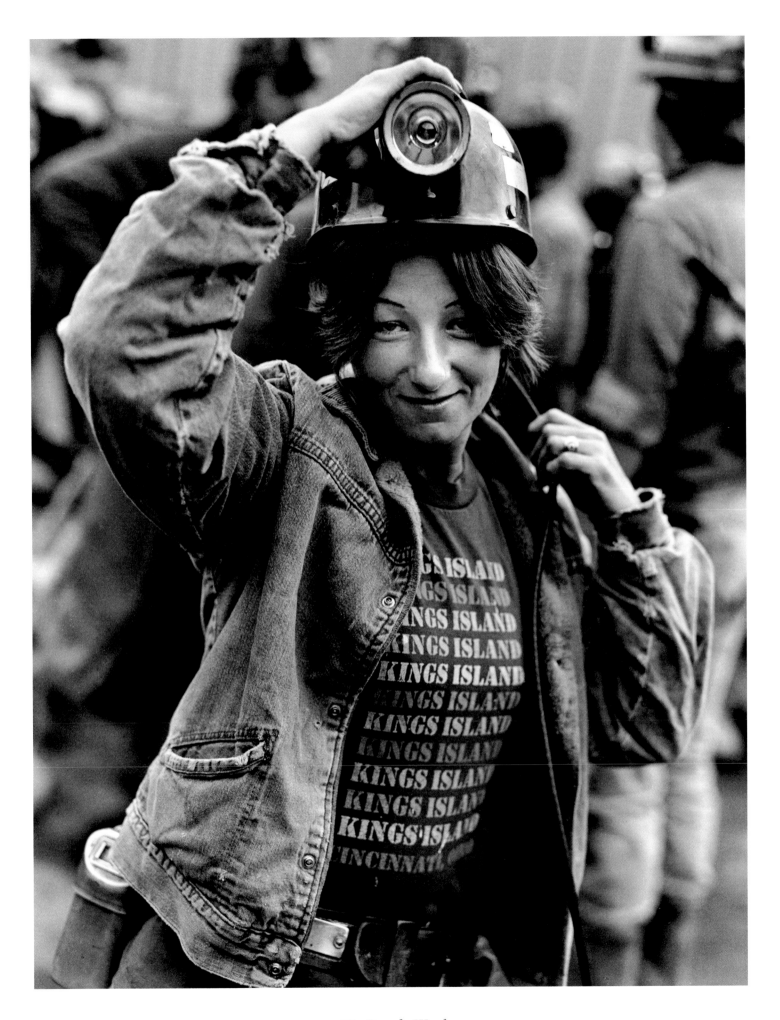

50 · Brenda Ward

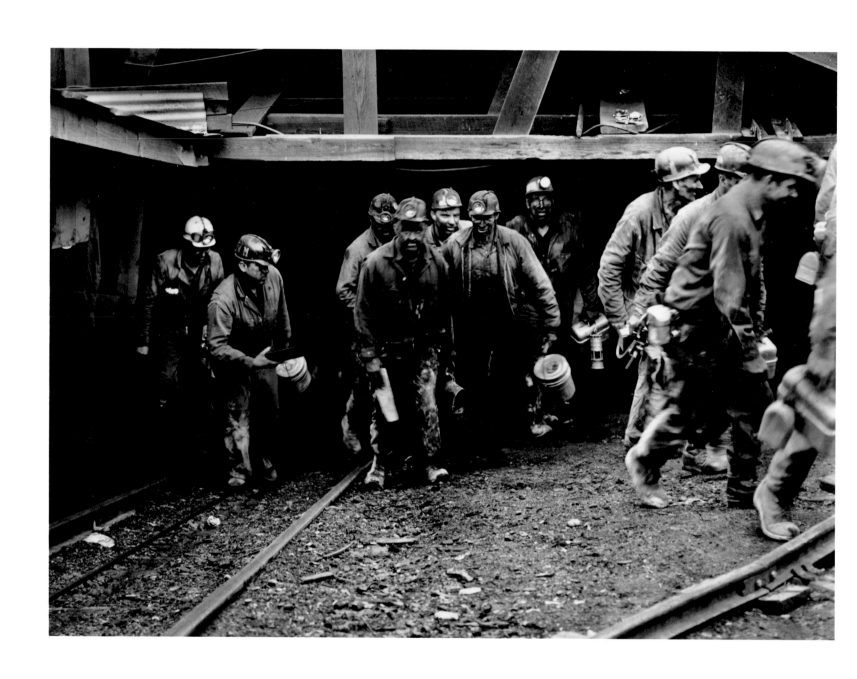

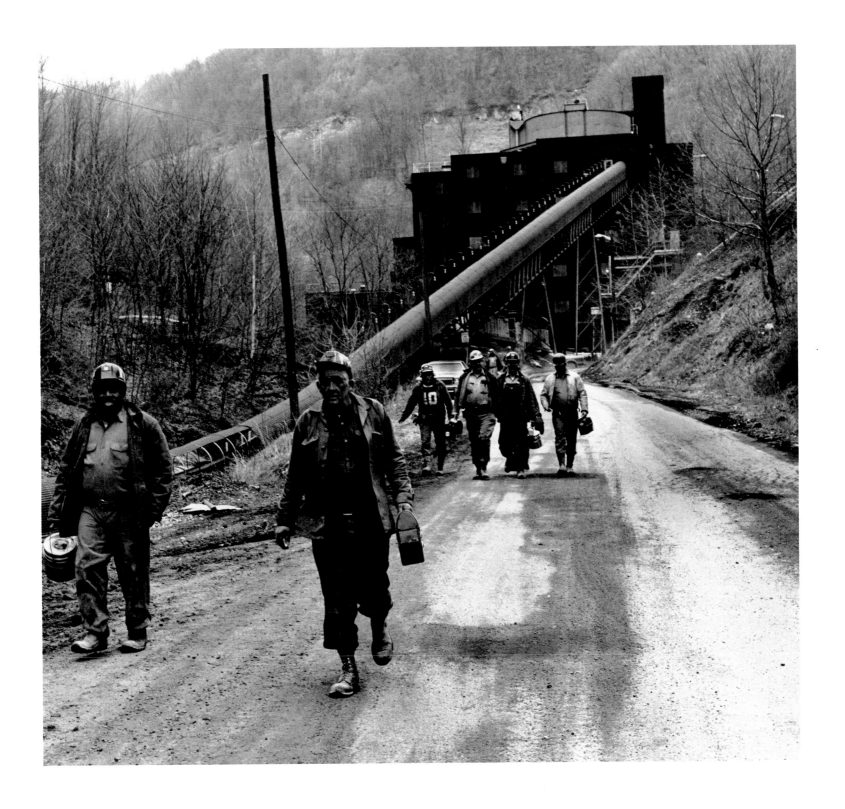

MOUNTAINTOP REMOVAL AND SLURRY IMPOUNDMENTS

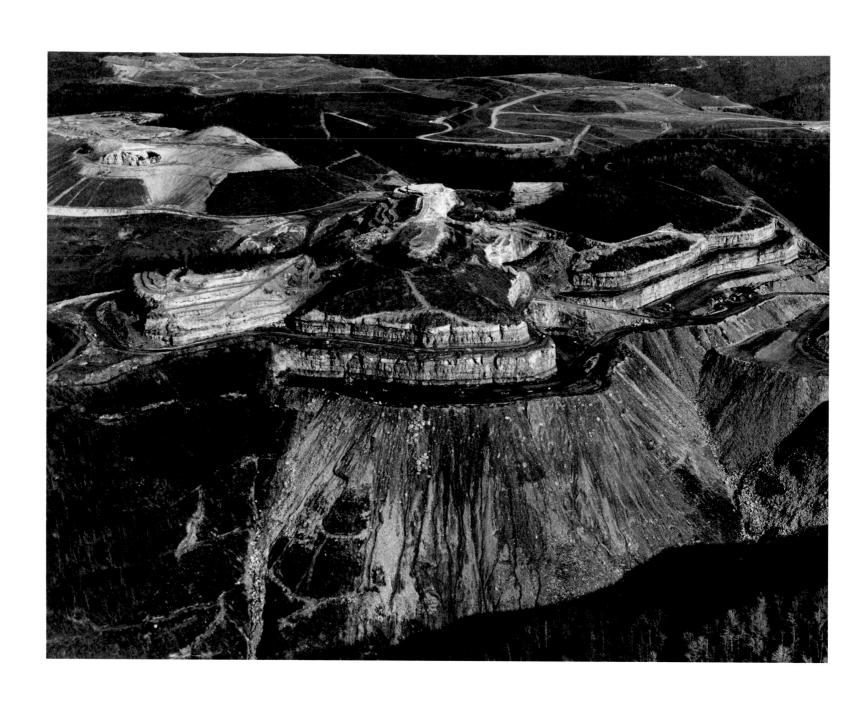

53 · Mountaintop Removal Mine

53 *Mountaintop Removal Mine* with Valley Fill, southern West Virginia, 2004. Coal companies are able to get coal faster and more cheaply by blasting off the tops of mountains than by traditional methods. The blasted top, the overburden, which is full of chunks of rock and pulverized rock containing dissolvable poisonous heavy metals, is bulldozed or dumped from a truck over the mountainside, burying streams and becoming valley fill. The exposed coal is then scooped out by giant mechanized shovels called draglines. Once the top seam of coal is removed, the blasting process can be repeated as many as six to eight times to reach successive coal seams. Along with the clear-cutting that usually precedes it, mountaintop removal mining increases the probability and intensity of flooding in the communities in the hollows and valleys below. During storms, the rainwater gushes down the valley fill as if in a giant funnel, carrying the dissolvable heavy metals. Sometimes the valley fill gives way, causing massive mudslides. According to Jack Spadaro, formerly superintendent of the National Mine Health and Safety Academy and longtime expert on mine safety and health issues, "Unless [these] mining practices ... are controlled far more strenuously or curtailed, by the year 2014 more than 3,000 square miles of Appalachian mountains, forests, and streams will have been utterly destroyed. At least 3,500 miles of stream will have been filled up and obliterated with highly toxic mine spoil."

54 *Demolition Crew and Blastholes,* Bluestone Mining Corporation Surface Mine, Keystone, McDowell County, West Virginia, 2004. Blastholes are made by a drilling rig. The holes, which may be as deep as 60 feet, are 6 inches in diameter and spaced about 10 feet apart. There may be only ten blastholes or as many as ninety for any given blast. Each hole is filled with ammonium nitrate (fertilizer) sprayed with diesel fuel oil. The mixture is called ANFO. A typical blast uses about 40,000 pounds of ANFO, ten times the amount that Timothy McVeigh used to blow up the Murrah Federal Building in Oklahoma City. After the holes are filled, blasting caps—detonators—are packed into each hole and then strung together with a long orange fuse. Once the rock is broken up, it is dumped or bulldozed over the side of the mountain.

55 *Dragline,* Hobet 21 Surface Mine, Boone and Lincoln Counties, West Virginia, 2006. After the trees are clear-cut from the mountaintop and the rock covering the thin high-quality coal seams is blasted off, a huge dragline several stories high with its giant shovel is brought in to scoop up the exposed coal and load it into trucks for transport to the prepa-ration plant. Hobet 21 is one of the largest mountaintop removal surface mines in Central Appalachia.

56 *Coal Refuse Containment Ponds* and Contoured Terraces, Raleigh County, West Virginia, 2004. The contoured terraces in the foreground, constructed of compacted coal refuse, are used to control water runoff. In the area below the terraces, trucks dump solid coal waste, which is spread and compacted. Above the terraces are coal slurry contain-ment settling ponds. They have become widely used over the years as a storage method that is safer than the usual large coal waste reservoirs. Because these slurry lagoons are small and shallow, they do not pose a threat of flooding to local communities should a dam or bottom break. But they are spread out over a far larger area, many on worked-out moun-taintop removal mine sites. Frequently, mammals and birds (by the thousands per month) are trapped in the toxic mire and die. A few surface-mine workers have died the same way.

57 *Brushy Fork Coal Refuse Impoundment,* Raleigh County, West Virginia, 2004. Owned by Marfork Coal Company, this slurry reservoir was a subsidiary of Massey Energy Corporation, now owned by Alpha Natural Resources. Permitted by the Environmental Protection Agency to extend 900 feet deep and to hold more than eight billion gallons of coal slurry, the Brushy Fork impoundment near the town of Whitesville is the largest coal refuse reservoir in Appalachia. The Mine Safety and Health Administration has listed it as having "high hazard potential." Up to sixty different chemicals, some of them known carcinogens, are used in washing the coal. In the process, the heavy metals that occur naturally in coal—including mercury, arsenic, lead, selenium, and cadmium—leach into the water. The resulting slurry has frequently been stored in coal waste impoundments, which often sit on top of abandoned underground mines. There are more than 713 such impoundments in the United States, about 500 of them in Appalachia. In 1972, the bulkhead of a coal waste lake in Logan County, West Virginia, broke, releasing millions of gallons of black, poisonous slurry down Buffalo Creek Hollow, killing 125 people, injuring more than 1,000, and leaving 4,000 homeless.

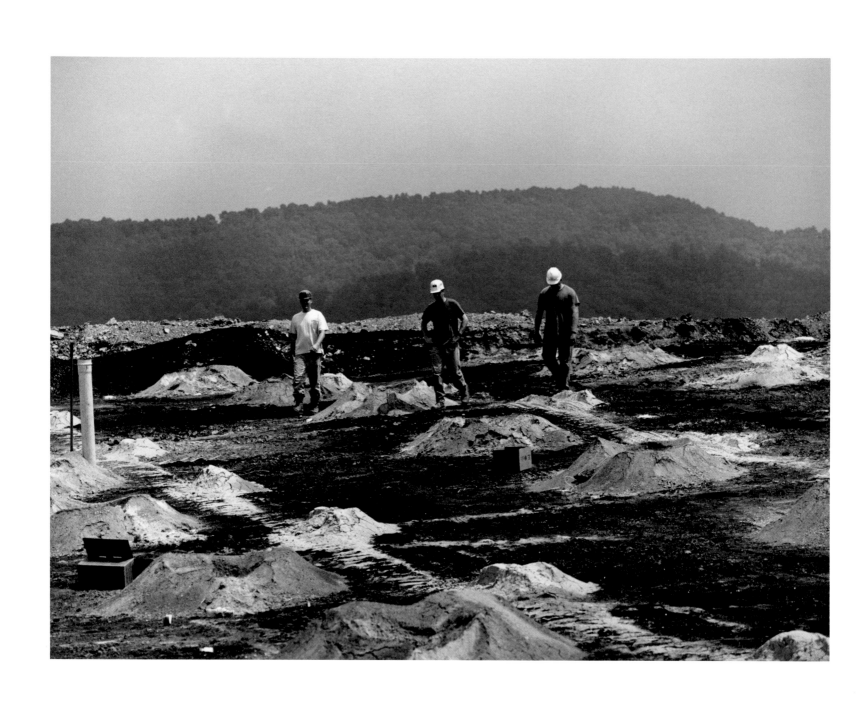

54 · Demolition Crew and Blastholes

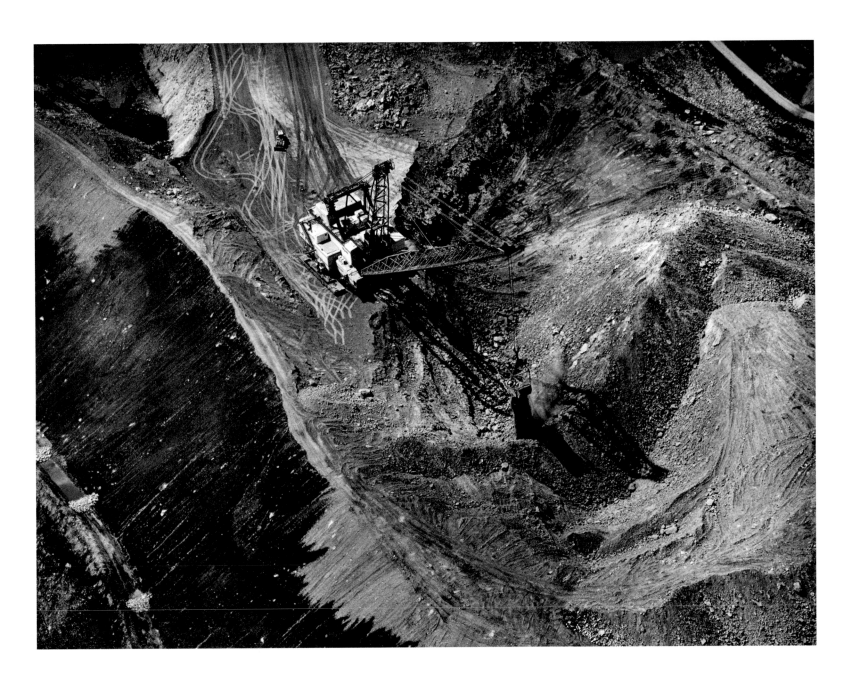

55 · Dragline

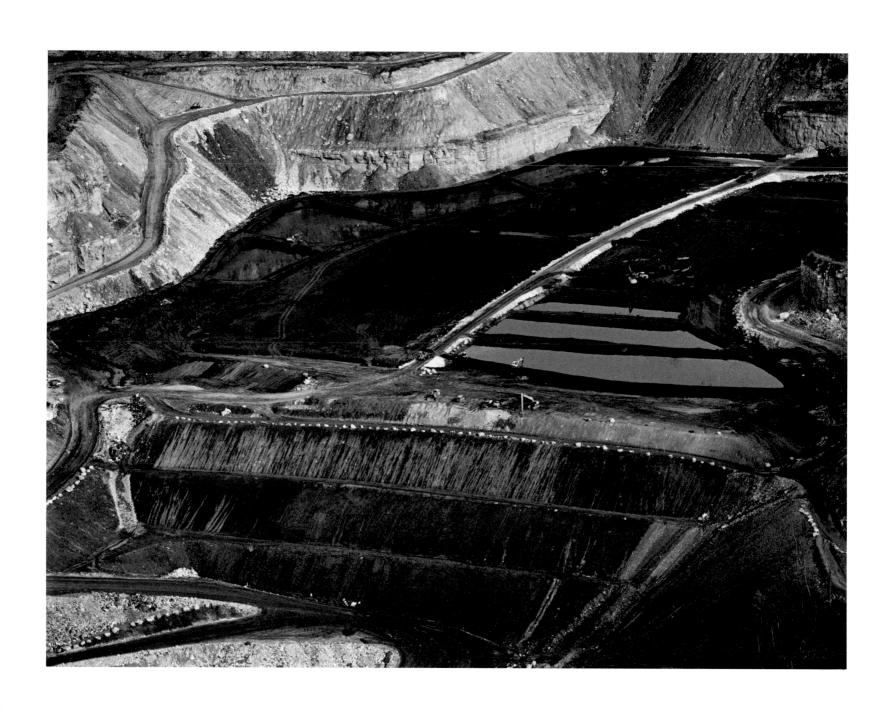

56 · Coal Refuse Containment Ponds

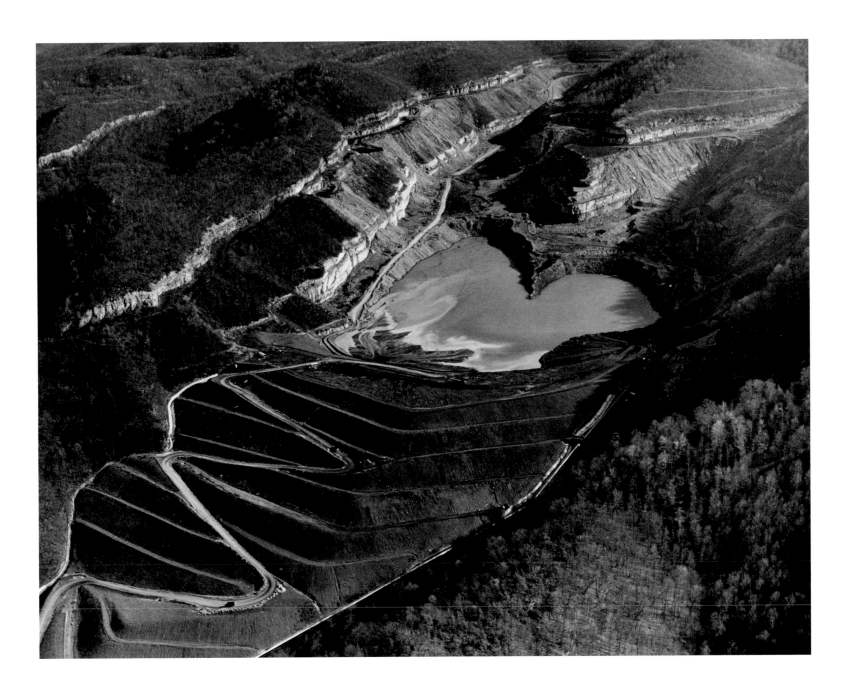

57 · Brushy Fork Coal Refuse Impoundment

58 *Brushy Fork Coal Refuse Impoundment Extension,* Raleigh County, West Virginia, 2004. When I made this photograph, flying less than 3000 feet above the site, it was empty, but within six years this section was full of coal slurry.

59 *Preparation Plant, Coal Silo, and Elementary School,* Sundial, Raleigh County, West Virginia, 2002. The proximity of the Goals Coal Company preparation plant and storage silos, 400 and 100 yards respectively, to Marsh Fork Elementary School and athletic field can be clearly seen from a small plane. After more than nine years of protests by local activists and their supporters, and after Massey's nearby Upper Big Branch Mine exploded killing twenty-nine miners (in 2010), Massey Energy, the owner of Goals at the time, agreed to help finance the construction of a new elementary school. Built five miles down the road in Rock Creek, it opened in January 2013.

60 *Chopping Branch,* McRoberts, Letcher County, Kentucky, 2003. As Eric Reece wrote (*Orion Magazine,* January/February 2006), "In 1998, Tampa Energy Company (TECO) started blasting along the ridge-tops above McRoberts. Homes shook and foundations cracked. Then TECO sheared off all of the vegetation at the head of Chopping Block Hollow and replaced it with the compacted rubble of a valley fill. In a region prone to flash floods, nothing was left to hold back the rain; this once-forested watershed had been turned into an enormous funnel. In 2002, three so-called hundred-year floods happened in ten days." Betty Banks, whom I visited there, told me that she had been flooded out five times from that May to July. Her garden of roses and other flowers was ruined, her basement a muddy mess. After the last flooding she finally acceded to TECO's many offers to buy her out and moved to a small house on the main road near the post office. "I couldn't take it any more!" Married at sixteen, she had moved into that Chopping Branch home with her first husband when she was nineteen and was still living there forty-two years later. Her two children were born and grew up there.

61 *Delbarton Coal Slurry Impoundment,* Mingo County, West Virginia, 2003. Near a small community in Hell's Creek Hollow off Pearl Hill Road, between Delbarton and Belo, sits this liquid coal waste reservoir. Larry Maynard, then an activist for the Ohio Valley Environmental Coalition, led me, together with a friend who had accompanied me from New York City, up a steep hill behind the community where he lived with his family. Carrying all my camera equipment, we hiked, bushwhacked, and climbed. When we finally reached the top of Pearl Hill, we could see the waste reservoir through the bare trees. Beneath the bottom of this man-made coal waste lake is a worked-out underground mine that closed in the 1930s. Should the impoundment bottom break through to the old mine, local residents feared the same devastation wrought in 2000 by the coal slurry spill in Martin County, Kentucky, could be visited upon them.

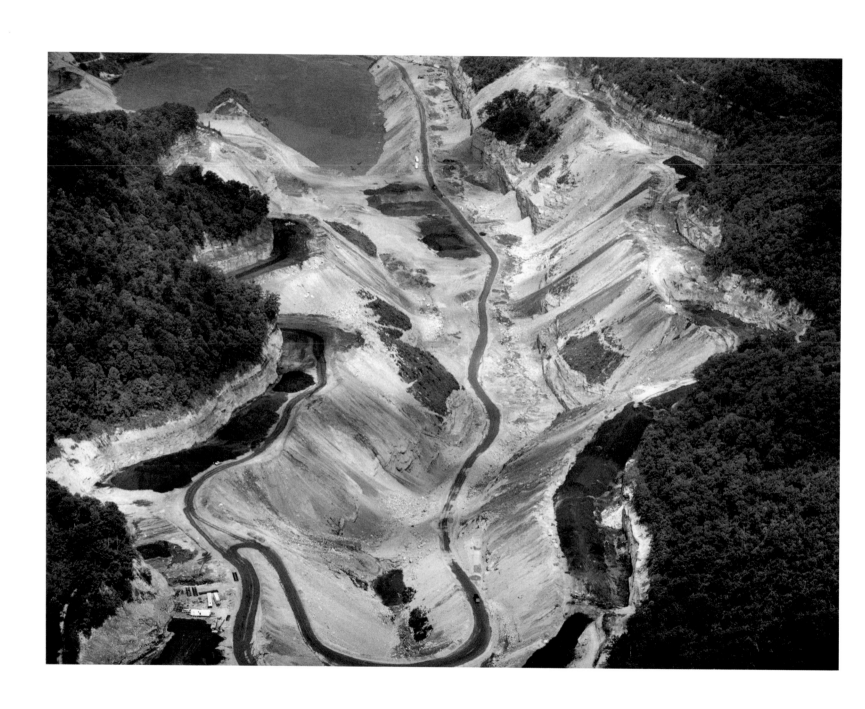

58 · Brushy Fork Coal Refuse Impoundment Extension

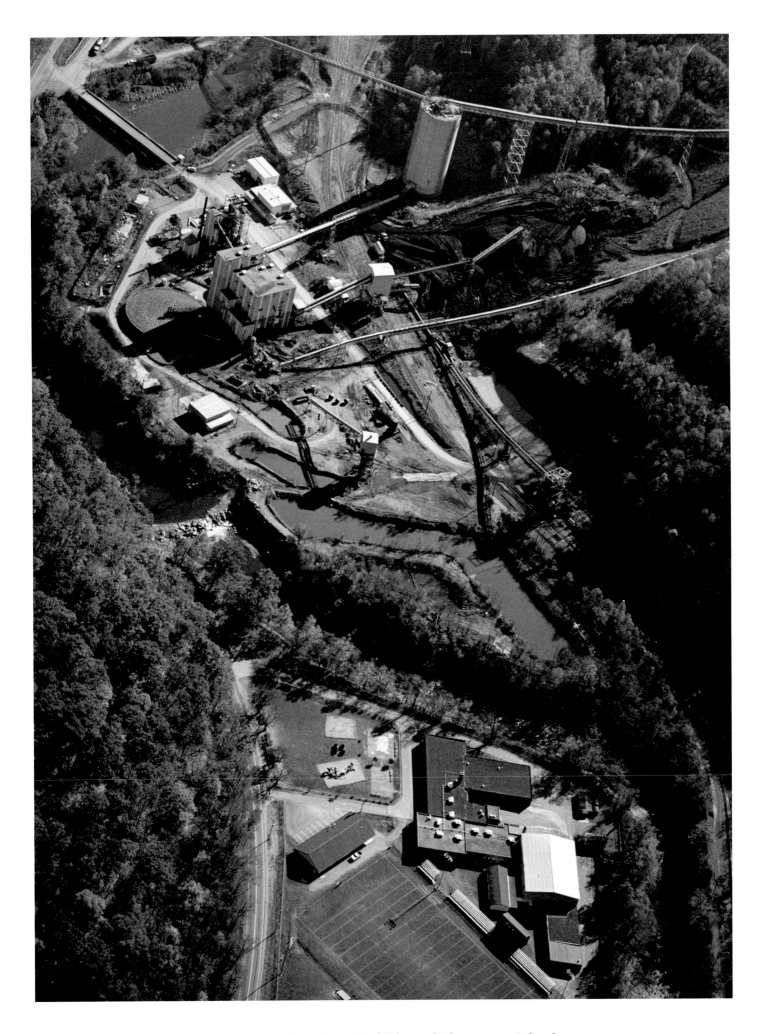

59 · Preparation Plant, Coal Silo, and Elementary School

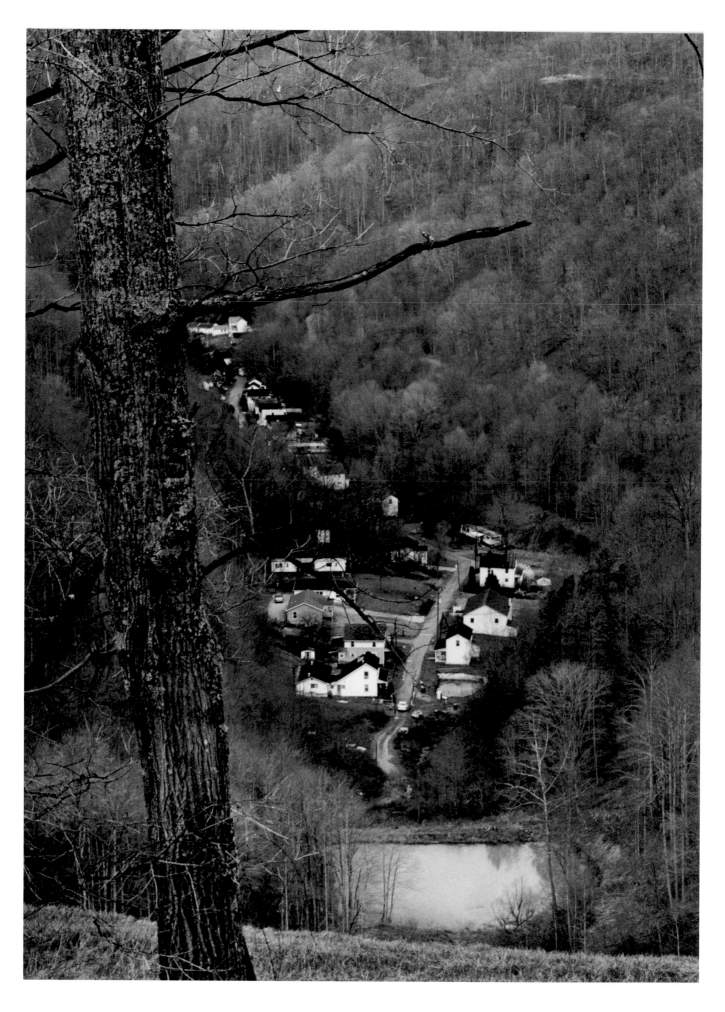

60 · Chopping Branch

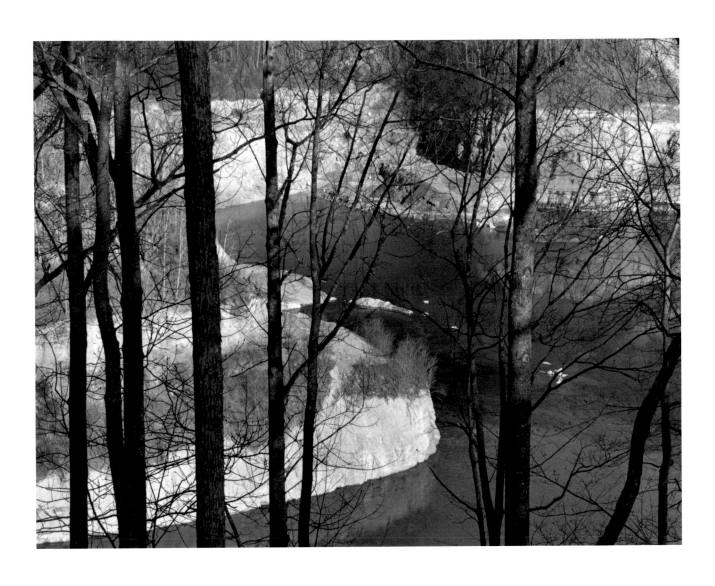

61 · Delbarton Coal Slurry Impoundment

STRIKE AND PROTEST

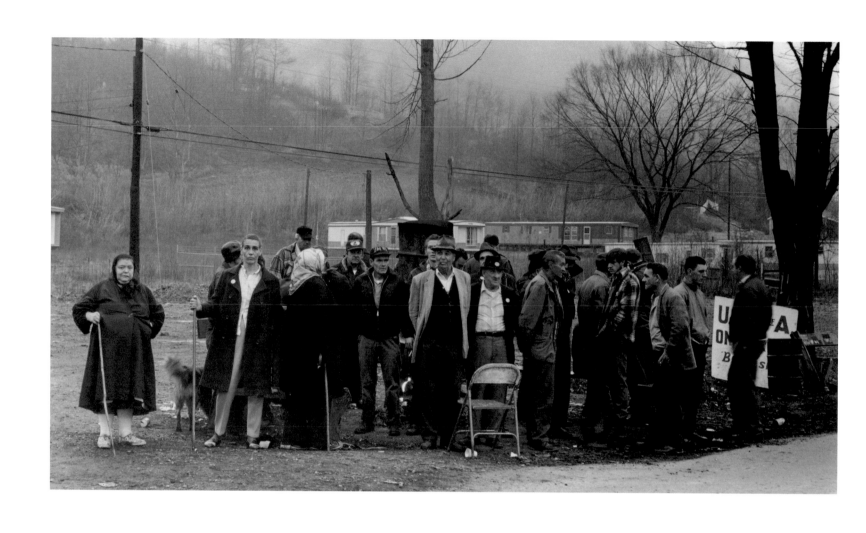

62 *Picket Line* for the UMWA, Brookside, Harlan County, Kentucky, 1973. Harlan County is well remembered for the violent suppression of union organizing by the coal operators. It is also known for the solidarity and resistance of the miners. In the first major attempt to unionize miners in eastern Kentucky since the 1930s, the United Mine Workers of America struck Duke Power Company's wholly owned subsidiary, Eastover Mining Company, at its Brookside mine and, a year later, at its Highsplint mine. Photographed on the day after Thanksgiving in 1973, these picketers were part of a thirteen-month strike in which one miner was killed. Crucial support from the miners' families and other community residents, the Brookside Women's Club, and the Tri-State Black Lung Association helped the UMWA win recognition.

63 *Striking Miners,* Highsplint, Harlan County, Kentucky, 1974. I returned to Harlan in the summer of 1974 because the strike against Duke Power's Eastover Mining Company, having spread to its Highsplint mine, had persisted, and I felt I needed more photographs about coalfield life. The year before, I had lived for a short time and become friends with the American photographer and filmmaker Paul Strand, who expressed an interest in my work. When I told him that I was going back to Appalachia, he insisted on giving me a small contribution toward the trip, saying, "This way I can be a part of your project." A UMWA organizer visiting Harlan from the national headquarters warned me against going to the picket line by myself because of the tense situation. Bill Worthington, from the African American community of Coxton and the president of the Tri-State Black Lung Association, offered to drive me to the picket line. Months earlier, the company had brought in the Ku Klux Klan in an unsuccessful effort to divide the miners and break the strike. Before I could get into Worthington's station wagon, he had to move his rifle, which had been lying across the front seat.

64 *Old Poster,* Fairview, Marion County, West Virginia, 2008. The president of the UMWA Fairmont local arranged for me to be escorted around Marion County on Election Day in 2008. The union had been campaigning for Barack Obama in Ohio, West Virginia, Pennsylvania, and elsewhere. One of the places we stopped was a union hall in Fairview, where I saw this poster, framed and hanging on the wall. Under the leadership of John L. Lewis, the UMWA played a key role in organizing the Congress of Industrial Organizations (CIO), including the steel and auto workers unions, and pioneered in health care for miners and their families, building eight hospitals in coalfield Appalachia.

65 *Brookside Women, Picket Line* for the UMWA, Harlan County, Kentucky, 1973. My wife, Alice, and I arrived in the town of Harlan, by car from New York City, on Thanksgiving evening. My contact Hobart Grills, a retired miner and the chairman of the Harlan County Black Lung Association, told me to go to the picket line at Brookside the next morning at 6 o'clock. Miners were striking against Duke Power Company's Eastover Mining Company for recognition of the UMWA at its Brookside mine. Sudie Crusenberry, a member of the Brookside Women's Club, is in the center with her cousin to her left. Willie Lunsford, behind and between the two women, told me that in the 1930s armed guards were posted at the entrance to their coal camp, preventing people from entering or leaving without company permission. The man on the right is Ewing Miracle.

66 *Permit Hearing,* Donna and Laura Beth Stover, Clear Creek, Boone County, West Virginia, May 2004. The local activist leader Julia (Judy) Bonds invited me to accompany her to a Department of Environmental Protection permit hearing at the Clear Fork Elementary School. The hearing was about Island Fork Coal Corporation's mountaintop removal mining taking place above and in back of Donna Stover's and several other families' homes. Her house and property were being threatened by the mining operations, including blasting that had continued for two years as of 2004, causing mud-slides behind her home and cracks in her well.

67 *Protest and Arrest,* Sundial, Raleigh County, West Virginia, 2009. A former West Virginia secretary of state and congressman, Ken Hechler, then ninety-four years old, was arrested along with twenty-nine others in a civil disobedience action, protesting Massey Energy's operating only a few hundred yards from the Marsh Fork Elementary School. I first met Ken, a longtime advocate for miners, at a Black Lung Association Rally in Mingo County in 1971. Also arrested for refusing to move after sitting down in the middle of Coal River Road in front of Massey Energy's Goals Mine Preparation Plant were Bo Webb, one of the protest's organizers; Judy Bonds, a Goldman Environmental Prize winner and co-director of the Whitesville-based Coal River Mountain Watch; the NASA climate scientist Dr. James Hansen; and the actress Daryl Hanna. Before the sit-down, about 350 activists had rallied and then marched to protest Massey's mountaintop removal mine and slurry reservoir. Massey, at the time the largest coal operator and most virulently anti-union company in the Appalachian coalfields, brought a large contingent of its workers (who were told their jobs were being threatened by the activists) to the demonstration in an attempt to shout down and intimidate the protesters. The protesters were demonstrating not only against Massey's coal operations at Sundial, but also against its anti-community and anti-mine-worker practices as well—throughout the county, state, and region.

68 *For Miners and Mountains,* State Capitol, Charleston, Kanawha County, West Virginia, 2005. Demonstrators protested the practice of mountaintop removal mining, which destroys not only the mountains but also many of the coal communities that have existed for generations in the valleys, hills, and hollows. The demonstration was also in support of underground miners and mining, which is much less destructive to the natural and social environment. Many of the local activist leaders, from mining families themselves, were present, including Judy Bonds, Charlene Canterberry, Larry Gibson, and Maria Gunnoe. Work above ground done by heavy machine operators, truck drivers, and demolition crews in mountaintop removal mining provides far fewer jobs than underground mining.

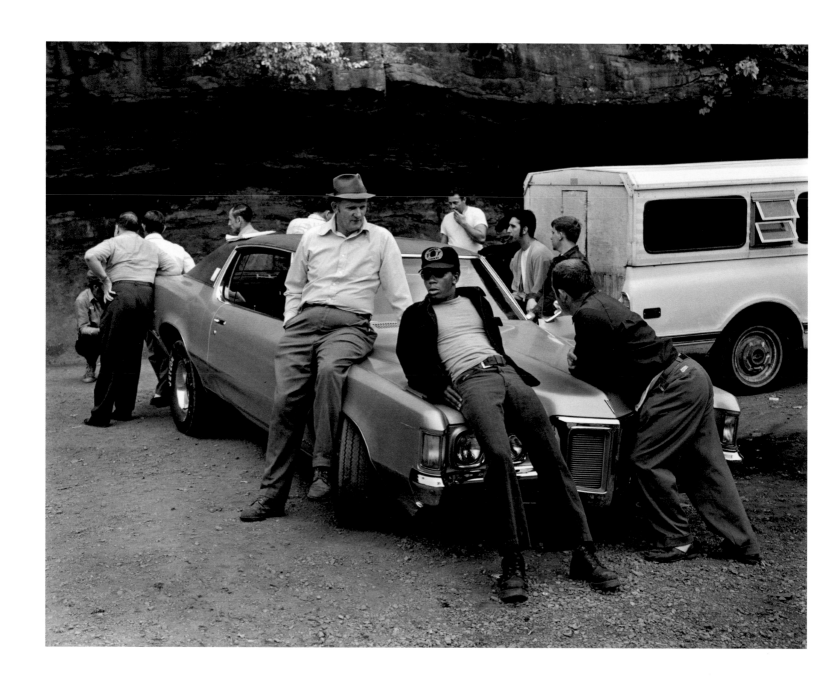

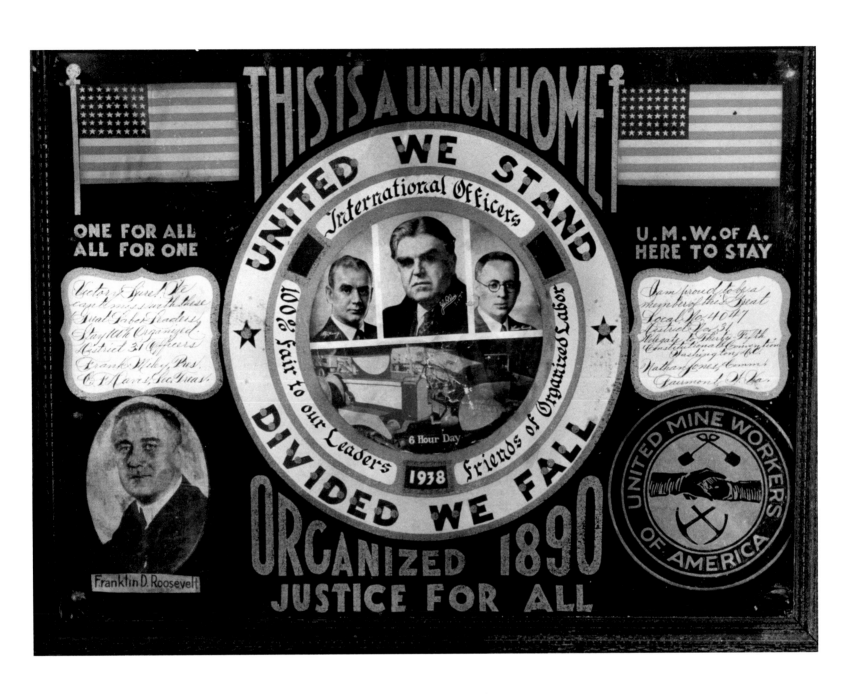

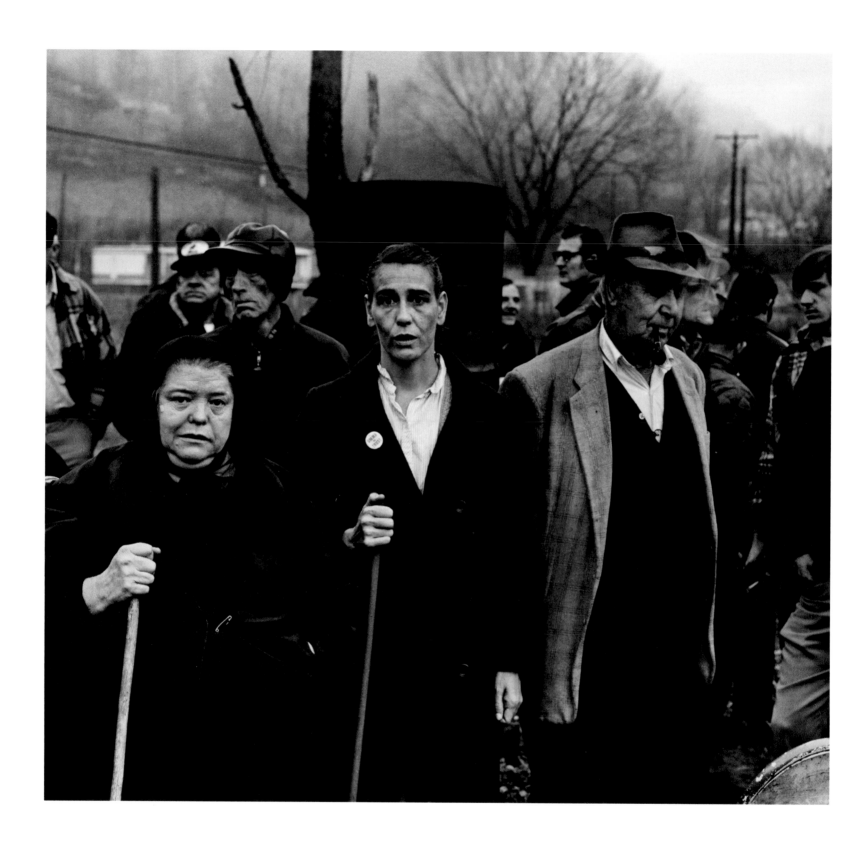

65 · Brookside Women, Picket Line

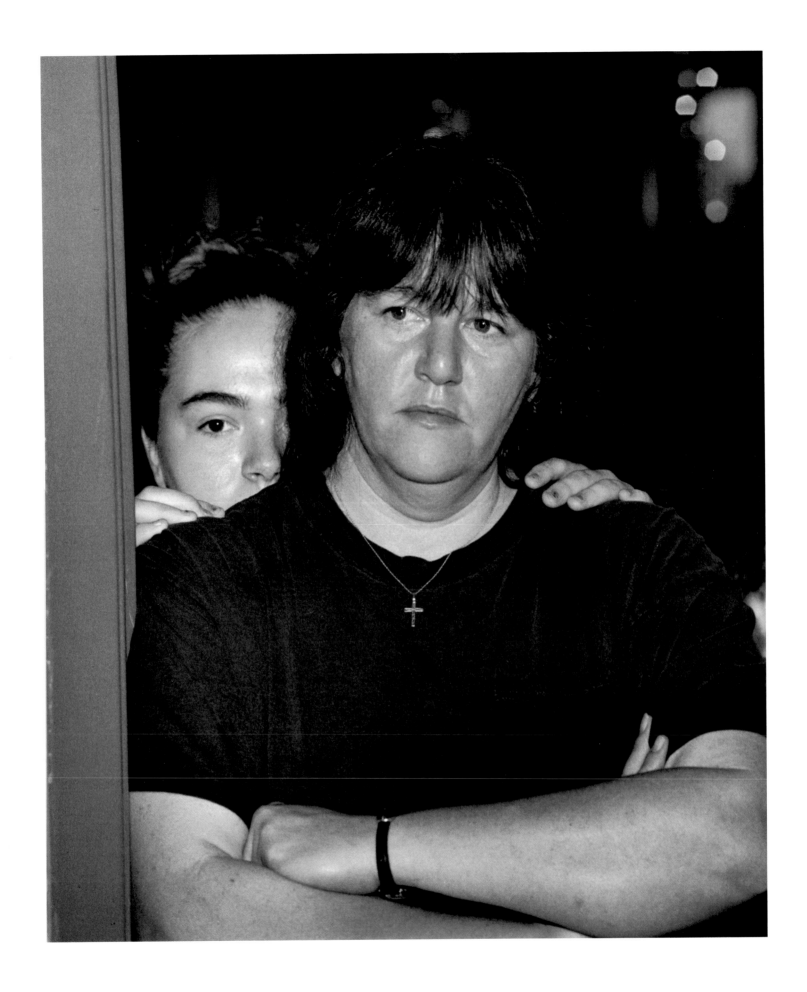

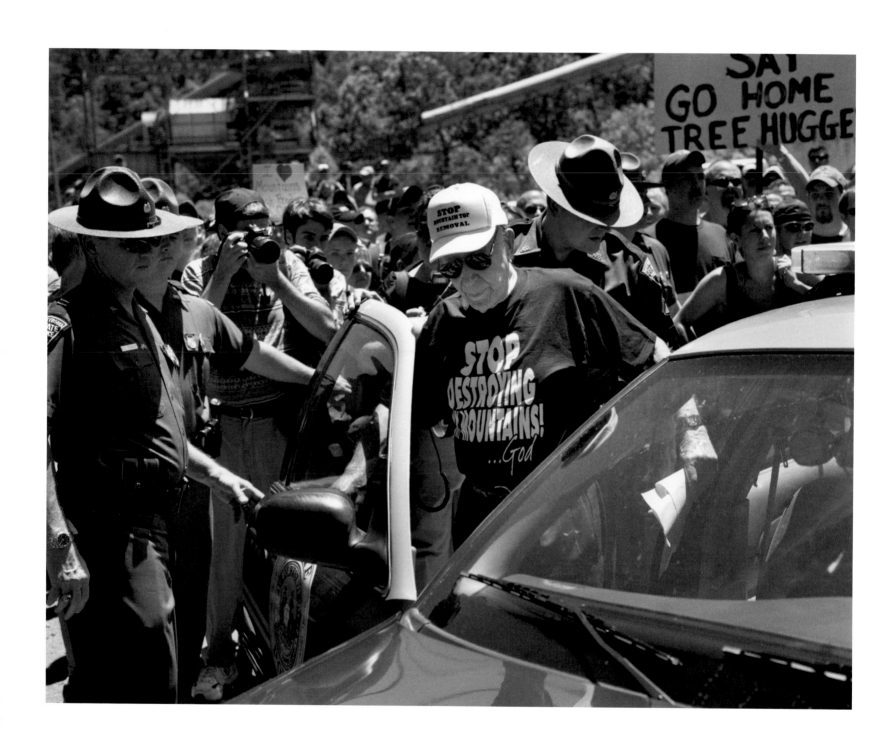

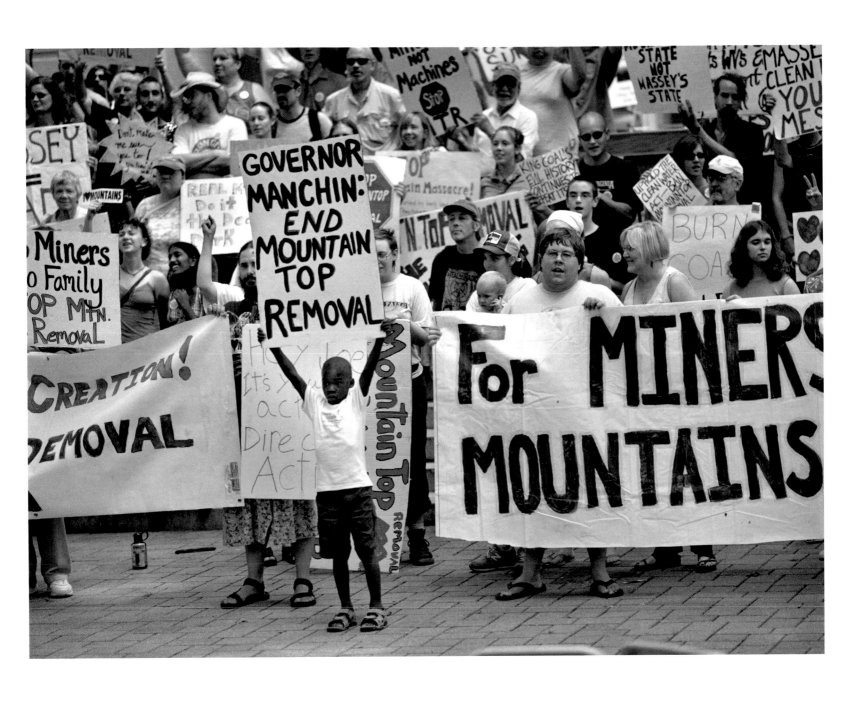

Artist's Statement

I GREW UP during the Cold War and the McCarthy era in a family that encouraged art and believed that the world needed to be changed. By the 1960s, I thought of myself as an abstract expressionist, trying to make art like de Kooning, Rauschenberg, and Chamberlain: full of directed spontaneity, raw energy, sensuality, and gritty vitality that spoke to me of real life. At that time, people in our nation were marching in the streets for civil rights at home and for peace in Vietnam. In communities throughout America, people were standing up for their humanity and dignity and struggling for social justice.

As an artist, I needed to find a way to have a direct connection to these social realities. My explorations in paint and steel left me unsatisfied. My paintings and sculptures did not sufficiently express what was in my heart and mind, nor adequately reflect the world outside. Making photographs was different. With the camera I was able to immerse myself directly into real life itself. I could abstract, compose, and intensify aspects of often chaotic, fluid reality within the rectangle of my viewfinder. With the release of the shutter, I could begin to physically create a new consciousness in and of the world. In the darkroom, I could further intensify and complete the process in the making of a photographic print. I have been inspired by the many great photographers who, for more than a century, had been creating work grounded in realism infused with an intense humanity, among them Eugène Atget, Lewis Hine, Henri Cartier-Bresson, Paul Strand, Dorothea Lange, Walker Evans, Helen Levitt, W. Eugene Smith, Roy DeCarava, and Robert Frank. I have striven to be a part of and contributor to that continuum.

—BL

Biographical Summaries

BUILDER LEVY was born in Tampa, Florida, in 1942 and raised in Brooklyn, New York. He received a BA in art from Brooklyn College (1964), where he studied painting with Ad Reinhardt, photography with Walter Rosenblum, and art history with Milton Brown. He studied the Photo League and the photography program of the Farm Security Administration in conjunction with his master's degree in art education at New York University (1966). Close friendships with Paul Strand and Helen Levitt (during the 1970s) provided greater insight into his role and possibilities as an artist.

Builder Levy's photographs intertwine the traditions of fine art, social documentary, and street photography. He has been awarded fellowships from the John Simon Guggenheim Memorial Foundation (2008), the Alicia Patterson Foundation (2004), the Puffin Foundation (2001), and the National Endowment for the Arts (1982). He is also a recipient of a Furthermore publication grant (2003) and two commissions from the Appalachian College Association (1995, 2002). Monographs of his work are *Images of Appalachian Coalfields*, with a foreword by Cornell Capa (1989); *Builder Levy Photographer*, with an introduction by Naomi Rosenblum (2005); and *Appalachia USA*. He published *Life of the Appalachian Coal Miner*, a limited-edition Stonetone portfolio printed by Sidney Rapoport (1976). His work is included in twenty-five other books.

Levy's work has appeared in more than two hundred exhibitions, including more than fifty one-person shows: in New York City, throughout the United States, and around the world. The exhibition *Images of Appalachian Coalfields* traveled from 1989 to 1997; more than 70,000 people saw it when it was shown at the West Virginia State Museum in Charleston in spring 1991. A show of his Appalachian work was exhibited in the Doris Ulmann Galleries at Berea College in 2008. Also in 2008, the High Museum of Art included Levy's work in *Road to Freedom: Photographs of the Civil Rights Movement, 1956–1968*. The Rubin Museum of Art in New York City featured his photographs in *Mongolia: Beyond Chinggis Khan*, in 2006–07. He was included in the Asia Society's exhibition *Coal + Ice*, which opened at the Three Shadows Photography Art Centre, Beijing, in 2011. His current project, *Developing Nations* was shown at the Flomenhaft Gallery in New York in 2012, and reviewed in *ArtNews*. A retrospective exhibition of Levy's work is scheduled to be at the Arnika Dawkins Gallery as part of Atlanta Celebrates Photography in October 2014.

His photographs are in more than fifty public collections in the U.S. and abroad, among them the Museum of Fine Arts, Houston; the High Museum of Art; the International

Center of Photography; the Brooklyn Museum; the Museum of the City of New York; the Victoria and Albert Museum in London; and the Bibliothèque nationale in Paris.

Among Levy's major projects are New York City (where he was a teacher of at-risk adolescents for thirty-five years), Appalachia, civil rights and peace demonstrations in the 1960s and the new millennium, and developing nations.

DENISE GIARDINA is the author of six novels, the play *Robert and Ted* (2012), and numerous articles. Her novel *Storming Heaven,* based on the miners' struggles in the early twentieth century, was a Discovery Selection of the Book-of-the-Month Club and in 1987 received the W. D. Weatherford Award for the best published work about the Appalachian South. *The Unquiet Earth* (1992) received an American Book Award and the Lillian Smith Book Award. Currently writer in residence at West Virginia State University, Giardina was the Mountain Party candidate for governor of West Virginia in 2000 and is an ordained deacon in the Episcopal Church.

Acknowledgments

DURING the more than four decades I worked on this project, numerous people, organizations, institutions, and associations throughout the Appalachian coalfields as well as others from outside the region helped make possible these photographs and this book. Among them are:

Rudy Abramson, Tom Acosta, Thomas Allen, Hanna and James T. Bartlett, Jean Battlo, John A. Bennette, Judy Bonds, George Brossi, Alice Brown, Pauline Canterberry, Cornell Capa, Mike Caputo, Alvin Cline, Robert Coles, Suzette Cook, Dave Cooper, Julian Cox, Betty Dotson-Lewis, Larry Easterling, Margaret Engel, Mari-Lynn Evans, Larry Fink, Janet M. Francendese, Larry Gibson, Maria Gunnoe, Abby Hayhurst, Loyal E. Jones, Felice Jorgeson, Janet Keating, David Blue Lamb, Susan Lapis, Davitt MacAteer, Deborah S. Marsh, Janet Martin, Eddie Miller, C. E. Morgan, Teresa Morris, Inga Motley, Sharon Mullins, Troy and Pearl Muncy, Jen Osha, Walter Rosenblum, Harry Shaw, Larry Shinn, Kem Short, Fred Stinson, Vivian Stockman, Paul and Hazel Strand, Della Hardman, Marsha Timpson, Rich Trumka, Ian Tummon, William H. Turner, Bo Webb, Don West, and Joseph Williams

Alicia Patterson Foundation, Appalachian College Association, Appalachian Voices, Appalshop, Berea College, Big Creek People in Action, Coal River Mountain Watch, Friends of West Virginia Culture and History, John Simon Guggenheim Memorial Foundation, Keeper of the Mountains Foundation, Kentuckians for the Commonwealth, McDowell County Board of Education, McDowell County, West Virginia State Office of Miner's Health, Safety and Training, Ohio Valley Environmental Coalition, Parkersburg Art Center, SouthWings, Temple University Press, United Mine Workers of America

Jack Spadaro shared his technical knowledge of all things relating to the coal industry. Paul Nyden shared his understanding of miners' struggles and heritage. Naomi Rosenblum provided invaluable help in the book's organization; the text and photographs were pulled together seamlessly by Jerry Kelly's design; Sarah Weiner patiently and carefully edited the texts; Martin Senn's separations allow the photographs to come alive on the page. Many thanks to Denise Giardina for her personal foreword. I am indebted to Patricia Vitacco for sharing her invaluable insights. Special thanks to David R. Godine for his belief in my photographs and this book.

Loving thanks to my brother, Jay, an early compatriot—and competitor—in art and life, and our late lively sister, Anita: they helped shape my way of seeing the world. To my parents, Vivian and the late Harold J. Levy, go my deep and continuing appreciation for their love and their vision. To my wife, Alice Deutsch, who has been my steadfast partner, toughest critic, and most ardent fan, I offer my deepest gratitude for her friendship and love.

—BL

Set in Miller and Scotch types.
Printed on Phoenix Motion Xantur paper at
GHP, West Haven, Connecticut. Bound by Acme Bookbinding.
Tritone separations by Martin Senn.
Designed by Jerry Kelly.

A special edition
of 150 signed and numbered copies of this book,
each enclosed in a hand-made slipcase, has been made,
75 of which include an original hand-printed
platinum or gold-toned gelatin
silver photographic print.

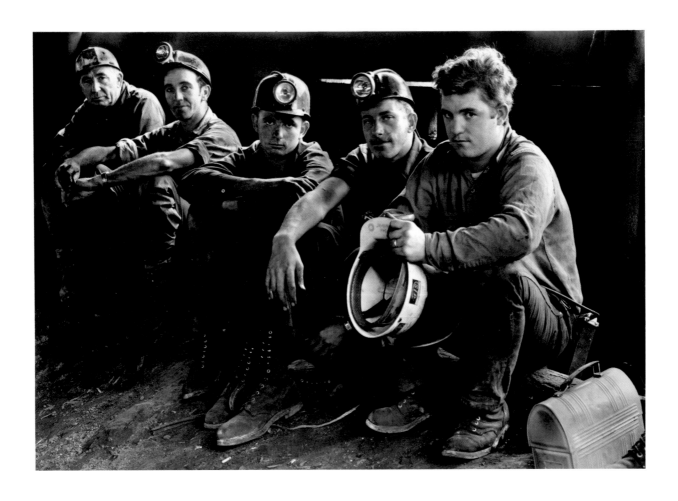

Morning Shift, Wolf Creek Colliery, Martin County, Kentucky, 1971